IMAGES
of America

MISSOURI STATE PENITENTIARY

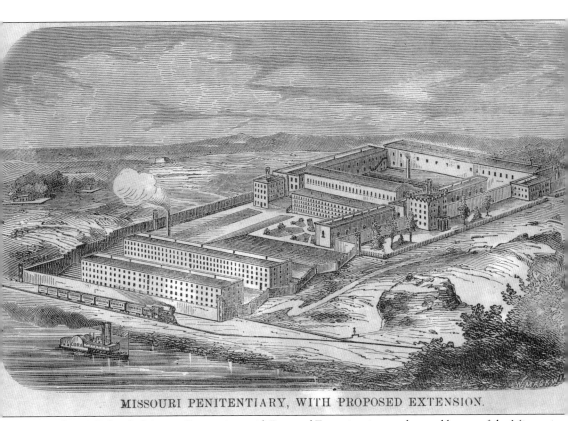

MISSOURI PENITENTIARY, WITH PROPOSED EXTENSION.

This 1869 sketch, *Missouri Penitentiary with Proposed Extension*, is an enhanced layout of the Missouri State Penitentiary site. The drawing presents the concept of a penitentiary complex with many buildings within the prison compound. The entire prison property is surrounded by a high wall with the Missouri River on one side of the penitentiary and barren land on the other three sides. A steamboat cruises the river near the institution, and a train runs next to one prison wall.

ON THE COVER: A horse and wagon are pictured near an alley where Missouri State Penitentiary prison shops operated about 1900. A prison guard stands on top of the wall near a guard tower, and a second person is at the base of the tower near a door. The old prison hospital is the building on the left.

IMAGES
of America

MISSOURI STATE PENITENTIARY

Arnold G. Parks

ARCADIA
PUBLISHING

Published by Arcadia Publishing
Charleston, South Carolina

Printed in the United States of America

Library of Congress Control Number: 2012943146

For all general information, please contact Arcadia Publishing:
Telephone 843-853-2070
Fax 843-853-0044
E-mail sales@arcadiapublishing.com
For customer service and orders:
Toll-Free 1-888-313-2665

Visit us on the Internet at www.arcadiapublishing.com

CONTENTS

ACKNOWLEDGMENTS

I am truly grateful to all of the individuals who supported this book project. Most importantly, John Dougan and his staff at the Missouri State Archives gave me access to their material on the Missouri State Penitentiary and were gracious with their assistance in locating documents and important resources on the topic. Secondly, I will be forever grateful to Corey Scott for the technical expertise he gave in readying the images for submission to Arcadia Publishing and coordinating the submission of them to my editor there. Third, former Lincoln University colleague Craig Sturdevant, who now owns an environmental research firm, shared with me his knowledge of the prison site from some archeological/historical work done at the prison. Fourth, Mike Groose, a former warden at the prison, shared valuable insight related to the institution, which helped with my descriptions for many of the images. The support of the latter-mentioned individuals added both substance and depth to the content of this book. Additionally, the tour guides at the closed penitentiary site sponsored by the Jefferson City Convention and Visitors Bureau provided invaluable insight during my scheduled group tour.

Thanks also to my editor at Arcadia Publishing, Liz Gurley, for her assistance with keeping this project on target and her helpful suggestions after reviewing the images during the developmental stage. Last, but not least, to my wife, Lennette, thank you for your helpful suggestions and editing of the manuscript, keeping me focused and on target, and the love and encouragement—not just for this book but also in everything.

Unless otherwise noted, the images are courtesy of the Missouri State Archives.

INTRODUCTION

Jefferson City, Missouri, named in honor of the third president of the United States, Thomas Jefferson, became the seat of government and Missouri's capital city in the early 1820s, with the first capitol building completed in 1826. The Missouri General Assembly began holding formal sessions there around that time.

Gov. John Miller worked extremely hard for the Missouri prison to be constructed in Jefferson City. His rationale was that a prison would help the city maintain its status as the seat of state government. A bill, which the legislature passed in 1833, established the penitentiary and mandated that it should be placed in Jefferson City.

Master stonemason James Dunnica, who assisted with building the first capitol building in Jefferson City in 1826, was appointed to oversee construction of the new prison, and the Missouri Legislature appropriated $25,000 for the project. During construction in the 1830s, prisoners made bricks and worked in the construction of the facility. The initial prison population consisted of one guard, the warden, the first prisoners, the brick-making foreman, and his assistant. The first prisoner was incarcerated in 1835. There were 15 prisoners, with 11 from St. Louis, and all of them were incarcerated for larceny except one, who was imprisoned for stabbing a man during a drunken brawl.

The prison, which formally opened in March 1836, was built on 37 acres. Enclosed by high stone walls, it was commonly referred to as "The Walls." At one time, Missouri's penitentiary was one of the largest penal institutions for maximum-security inmates in the United States and served as Missouri's primary maximum-security institution. When the prison closed on September 15, 2004, it was listed as the oldest prison operating west of the Mississippi River. By contrast, the famous Alcatraz Prison in California at its maximum had 500-plus inmates, whereas the Missouri State Penitentiary at one time housed 5,200 inmates.

The Missouri State Penitentiary, like many prisons in the United States, operated at one time under a behavior-control model known as the Auburn System, which confined inmates in separate cells at night but allowed them to work together during the day. Inmates were kept in strict silence and could not speak to each other without permission. The prevailing notion was inmates could be reformed if they were kept in solitary confinement under a rigid system of discipline. This strict control was no longer in force when the prison closed.

By 1839, the Missouri General Assembly was concerned about the large amount of state funds used in maintaining the state's prison operation; therefore, lawmakers decided that the rehabilitation of prisoners was less important than the state remaining financially solvent. Consequently, the state decided to lease the prison and its inmates to private citizens. The result was a practice whereby convict labor became a profit center for some enterprising local businesspeople. By 1900, there were 2,000 Missouri State Penitentiary inmates, making it the largest state prison in the United States; however, labor union protests began to chip away at the system of exploiting inmate labor, and in time this practice was stopped.

Another distinguishing feature of the Missouri State Penitentiary during its existence from 1836 to 2004 was the violence that occurred within its stone walls. In the 1960s, popular national publication *Time* reported that the prison was "the bloodiest 47 acres in America." While the main penitentiary complex was on 37 acres instead of 47, the reference to violent behavior inside the walls was probably correct given the stabbings and other crimes against people cited in reports. Some have reasoned that because the prison was the state's only maximum-security penal institution, violence occurred because there was no other place to house "the worst of the worst." Not only was inmate violence evident, but also the amount of contraband discovered in the prison added to the negative atmosphere that circled the prison community. In the fall of 1996, a couple of members of the prison staff devised a plan to help ease tension between inmates and staff and to try to stop the flow of contraband coming into the prison. It involved reinstating a select unit with experience, called the Search and Response Team. This unit successfully slowed the flow of contraband into the prison.

The Missouri State Penitentiary served as the state prison from 1836 until it closed in 2004. In 1991, the name Missouri State Penitentiary was changed to the Jefferson City Correctional Center; however, in 2003, the name was changed back to the Missouri State Penitentiary in order that there would be no confusion between the old prison and the new one being built. In 2009, Missouri divided the 140-acre penitentiary property into two separate spaces: one area that was abandoned and now serves as a historical spot reserved for prison tours, and a second area that has been set aside for private development. As a result, a $66 million federal courthouse named for retired US senator Christopher Bond has been built on a portion of the old prison grounds. Future plans include redevelopment of office buildings and commercial establishments on the remaining site. Finally, in anticipation of future land development, Missouri has received a $2.3 million grant for land preparation and development. Included in the first phase of retrofitting the area has been a building demolition effort that removed several former structures, including the Education Building and prison chapel. A planned second phase will include razing the I Hall housing unit and a section of the east wall, as those penitentiary structures were thought to have minimal historical value and not considered important to the future plans of the prison redevelopment program.

Since the closing of the penitentiary, interest in touring the site has been considerable. As such, the local Jefferson City Convention and Visitors Bureau established a department to coordinate and lead scheduled prison tours of the decommissioned institution for the thousands of people who each year sign up.

One

THE EARLY YEARS

The first prisoner was incarcerated at Missouri State Penitentiary in 1836. Soon, convicted felons from cities and counties throughout the state were sent to the prison, and the population steadily grew. The numbers increased to such an extent that it soon became a "city within a city," with many inmate necessities, including uniforms, boots, shoes, and some personal hygiene items produced on-site through inmate labor. Also, some items crafted in the prison were sold outside the institution to the general public. This practice began many years of inmate contract labor. Moreover, entire Jefferson City industries were developed behind prison walls by local businesspeople who became quite wealthy from the sale of inmate-produced goods. This system was eventually phased out in the late 1800s because of bitter opposition from labor unions.

Another feature of the Missouri prison in the early years was the separate section set aside from the men's prison for women prisoners, known as Housing Unit 1. The working conditions were not good for the female inmates, who had unpleasant experiences such as working for a private manufacturer of denim smocks for 50 hours a week. Additionally, the early years saw a system that fostered silence, whereby there was no verbal communication between prisoners, and individuals were not segregated by the seriousness of their crime.

In 1868, from a physical structure standpoint, Housing Unit 4, more commonly was referred to as "A Hall," was completed using stone quarried on-site and mainly built with inmate labor. The prison warden at the time, Horace Swift, was the architect of A Hall. Over the years, the Missouri State Penitentiary has been widely recognized among correctional institutions for some of the innovations that were introduced there.

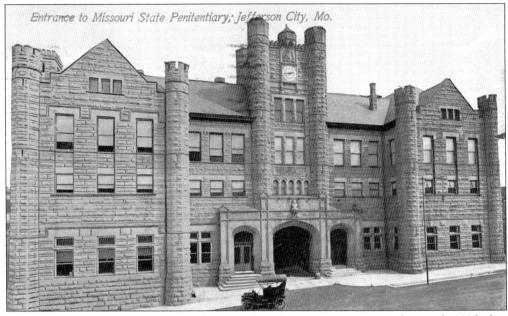

The Lafayette Street entrance to the Missouri State Penitentiary is pictured around 1910 before a new administration building was added in 1939 in front of this structure. The facade of the building is made of stone, as are the walls surrounding the penitentiary. The prison was nicknamed The Walls because of the stone wall that enclosed the site. (Parks collection.)

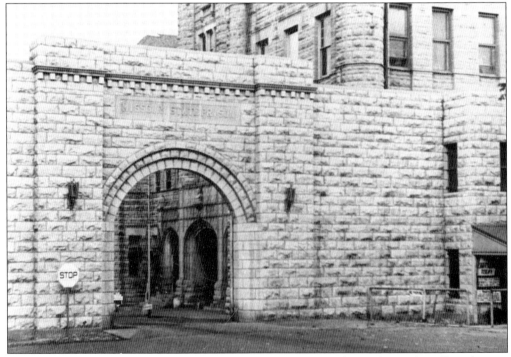

This 1920 photograph shows the stone wagon-gate entrance on Lafayette Street that allowed access to the main entrance to the penitentiary. The Central Administration Building (constructed in 1904–1905) is partially visible just beyond the arch. (Parks collection.)

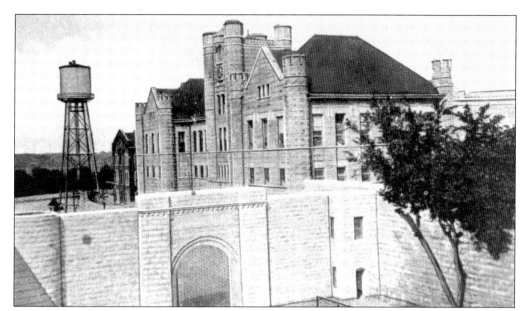

This is the wagon-gate entrance to the main penitentiary complex as seen on a 1912 postcard; the arched entryway in this photograph is hand drawn. In the extreme upper left are the prison water tower and the nearby prison hospital. (Parks collection.)

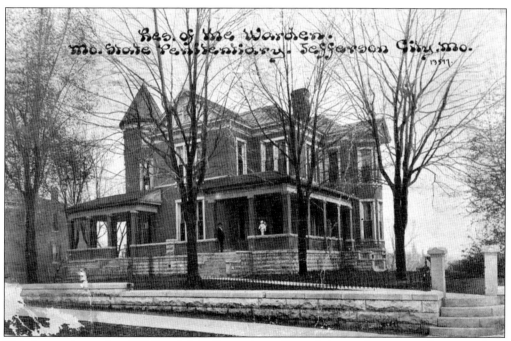

This house, located at 700 East Main Street (now Capitol Avenue), is across the street from the Missouri State Penitentiary. It was the prison warden's home and was provided to that administrator as a part of his salary package. The structure was built in 1888 by convict labor at a cost of $4,000. The lot on which the house was located cost $3,000. This residence was considered one of the finest houses in Jefferson City and reflected the prestige afforded the prison administrator. (Parks collection.)

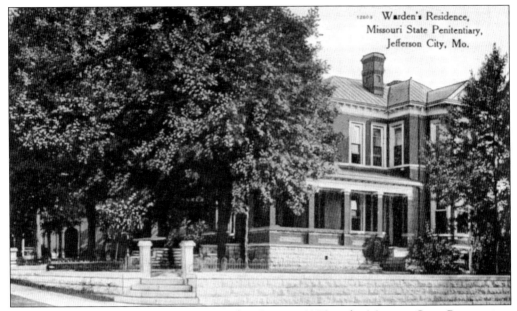

Col. Darwin W. Marmaduke was appointed in January 1885 as the Missouri State Penitentiary warden by his brother, Gov. John Sappington Marmaduke, and was the first person to occupy the warden's residence. Consequently, the home was referred to as the Marmaduke House. At one time, the director of corrections was required to reside here. When it was no longer mandatory, the building fell into disrepair until the 1990s, when a private owner purchased the structure and renovated it for attorney offices. (Parks collection.)

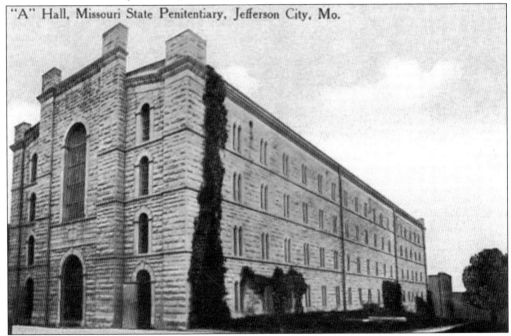

In 1868 Housing Unit 4, which is informally referred to as A Hall, was built by inmate labor with rock quarried at the prison site. It is the oldest building for housing prisoners among those still standing on penitentiary grounds. Missouri State Penitentiary warden Horace Swift was the architect.

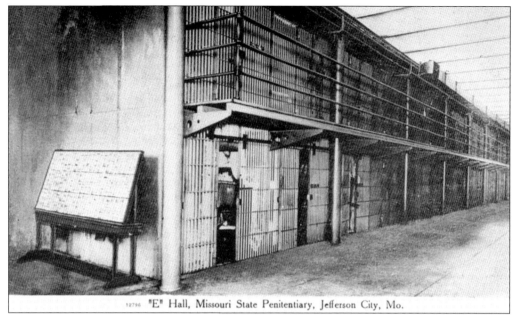

This is an interior view of the E Hall housing unit, which, along with A Hall, was among the first cell-block buildings constructed at the Missouri State Penitentiary. The box on the left front contains a housing list noting the individuals in each cell in this two-tiered cell building. The structure was badly damaged by fire in the 1954 prison riot and is no longer standing. The photograph here is a postcard postmarked 1909. (Parks collection.)

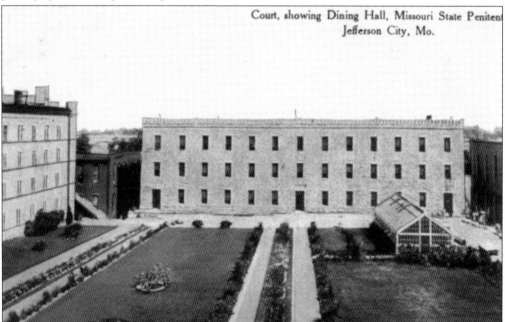

This early-1900s photograph shows the main prison courtyard. The building in the foreground contains the prison dining hall, and in front of it is a greenhouse with nicely landscaped shrubs and flowers planted along the walkways. The building on the left in this 1913 postcard is A Hall, where African American inmates resided when the prison was segregated. (Parks collection.)

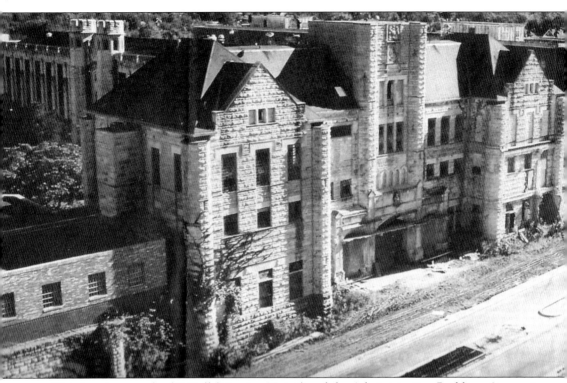

This is a photograph of H Hall (Housing Unit 1) and the Administration Building. At one time, this facility housed female federal prisoners because it was not until the late 1920s that a federal prison existed for women. When H Hall opened, two high-profile federal prisoners included prison-reform social activists Kate Richards O'Hare and Emma Goldman, who served time in this unit from 1917 to 1920. (Parks collection.)

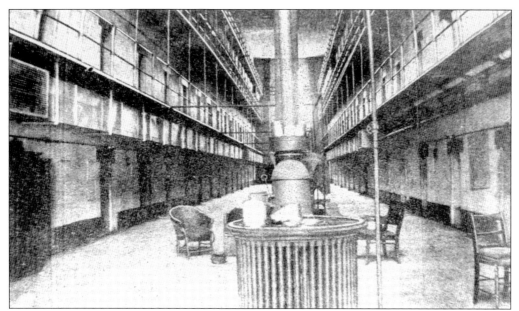

This interior photograph of the A Hall housing unit in the early 1900s shows the building's heating unit in the front center. A stove similar to this one caused a fire in 1927, which burned the roof off of the building. It was repaired in one week, which was considered an amazing feat given the extreme weather conditions in January of that year.

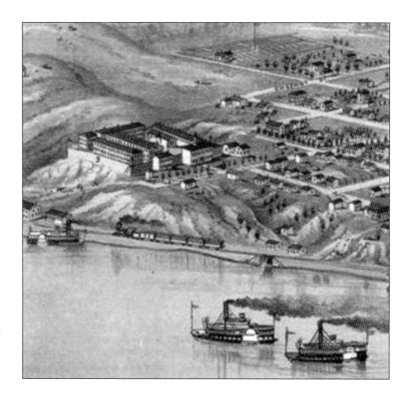

This section of a bird's-eye view of Jefferson City depicts the prison in 1869. (Courtesy of Craig Sturdevant.)

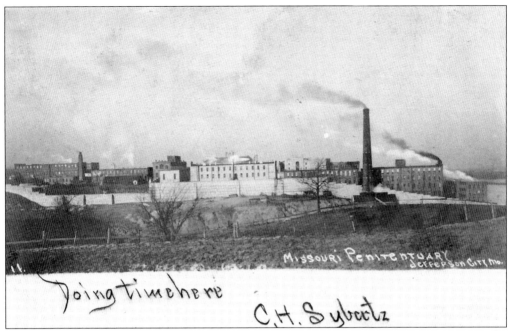

This postcard, dated July 27, 1906, was mailed from the prison to someone in St. Louis. The inmate wrote, "Doing time here."

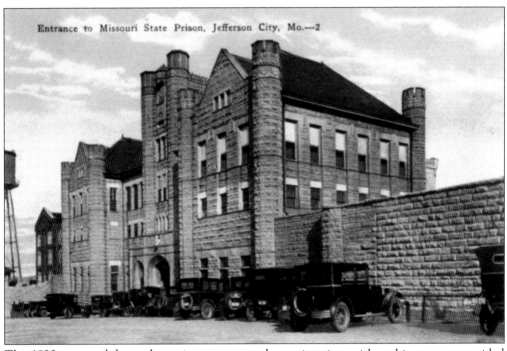

This 1920s postcard shows the main entrance to the penitentiary with parking spaces provided in front. The 30-foot-high grey stone wall, which surrounds 38 of the prison's 80 acres, connects to the building on both sides. The prison was located on a rocky setting overlooking the Missouri River.

This 1920s image is of the Missouri State Penitentiary courtyard. Notice the large fountain in the center of the yard near a walkway. On the left is Housing Unit 4/A Hall, and in the background is a prison shop; on the right is the old dining hall. Both inmates and staff are seen near the entrance to the dining hall. (Courtesy of Mark Schreiber.)

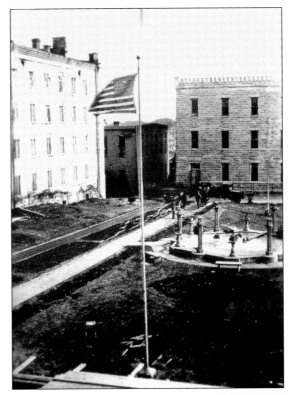

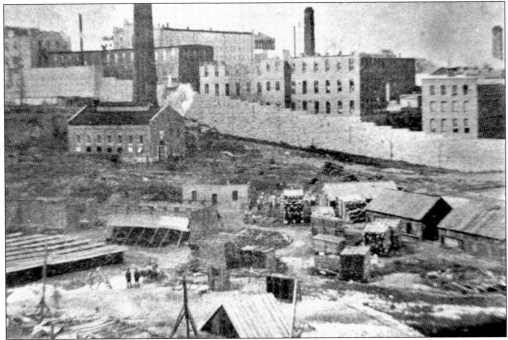

Here is a c. 1900 photograph showing the early development of the Missouri State Penitentiary site. The tall buildings in the background are on the prison grounds, whereas the buildings in the foreground are outside the prison walls. (Parks collection.)

Pictured around 1920, this courtyard scene shows the new dining hall on the left and the newly built McClung Hall on the right, later known as Unit 3 B and C Hall. There was an iron fence at the bottom on the far left enclosing A Hall, which is not evident in this photograph. The courtyard was well landscaped with a pool and fountain. (Parks collection.)

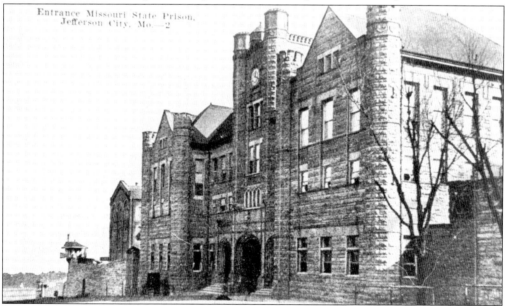

The main entrance to the Missouri State Penitentiary is shown in this photograph taken around 1904. A popular theory is that this building was constructed in phases because the wings on each end appear to have been added after the main administrative and women's housing sections were both completed around 1905. The image was taken from *The Missouri State Prison as Seen by a Convict Between 1913–1914*, a book written and compiled by convict No. 13,905, which supposedly contained the truth about everything that occurred inside the walls.

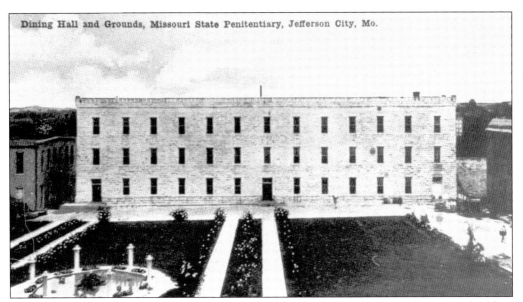

Dining Hall and Grounds, Missouri State Penitentiary, Jefferson City, Mo.

The dining hall and grounds are pictured here in the early 1900s. This large, three-story building contained a kitchen and a lower-level dining hall on the ground floor. A larger dining hall was on the second floor, and the chapel and library were on the top floor.

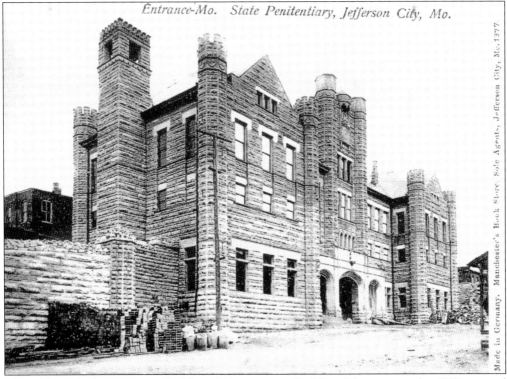

Entrance-Mo. State Penitentiary, Jefferson City, Mo.

This is the arched entryway to the Main Administration Building. The entry on this 1920 postcard appears to be hand painted. The actual entryway was an impressive structure, made with stone similar to that of the walls surrounding the prison.

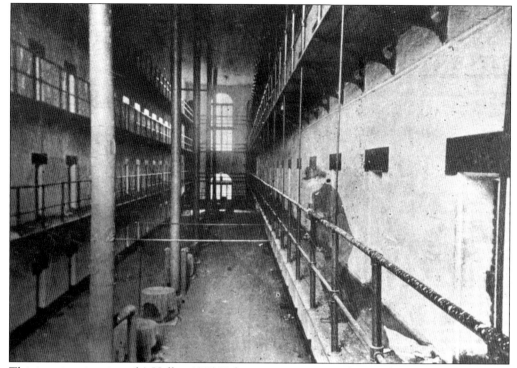

This is an interior view of A Hall in 1905. Either an inmate or guard is standing on one of the upper tiers. This housing unit had 152 cells and eight dungeon cells, located underground and known as "The Hole." At one time, A Hall had almost 750 inmates crammed into close quarters.

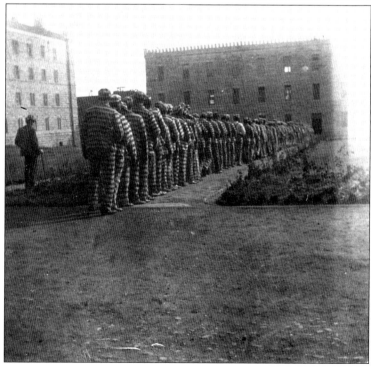

Inmates in striped uniforms are marching to a meal in the dining hall in this 1900 photograph. A Hall is on the left, with a guard in front swinging a stick.

Inmates are seen marching to a meal about 1900.

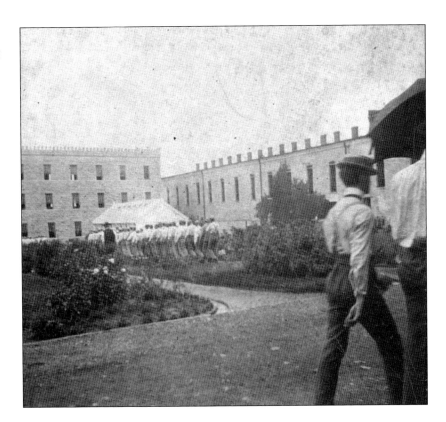

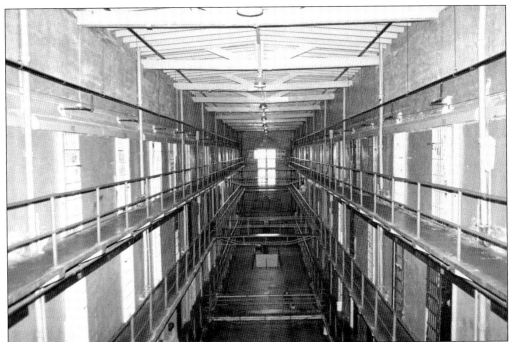

This photograph of A Hall was taken from a catwalk four stories high. This vantage point shows the beams under the roof. (Parks collection.)

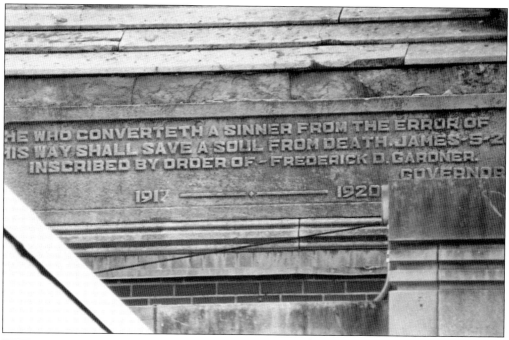

HE WHO CONVERTETH A SINNER FROM THE ERROR OF HIS WAY SHALL SAVE A SOUL FROM DEATH. JAMES 5-2 INSCRIBED BY ORDER OF - FREDERICK D. GARDNER. GOVERNOR 1917 — 1920

This inscription was above the front entrance of the Missouri State Penitentiary Main Administration Building, which was constructed between 1900 and 1905.

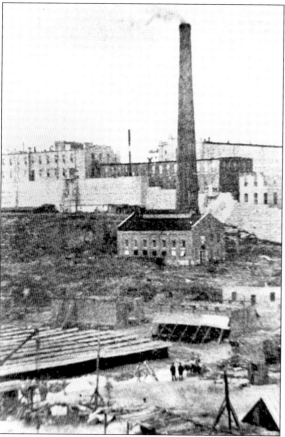

The prison compound is seen here around 1905.

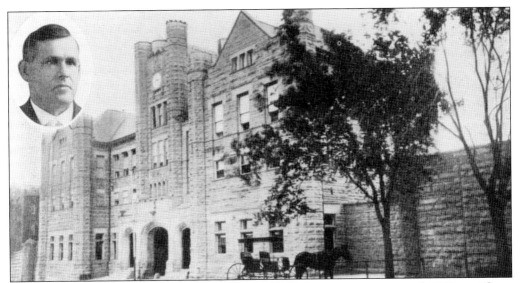

This photograph, taken between 1913 and 1914, shows the main entrance to the Missouri State Penitentiary that housed female inmates. The man in the photograph insert is O.C. McClung, who was the warden at that time.

The Isolation Building, constructed around the time of World War I, was located near the old E Hall and the prison hospital. This building, which is imposing with its stone construction, was demolished by 1935.

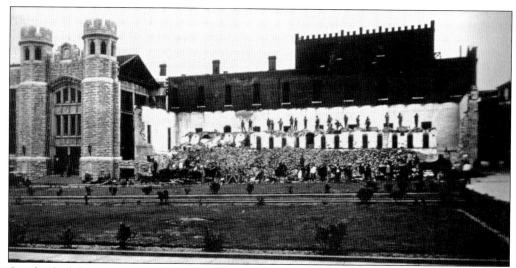

On the far left, a car passes in front of the entrance to the Missouri State Penitentiary in the early 1900s. Also evident on the far left of this postcard is a guard tower. The dark brick structure next to the stone Main Administration Building is the prison hospital.

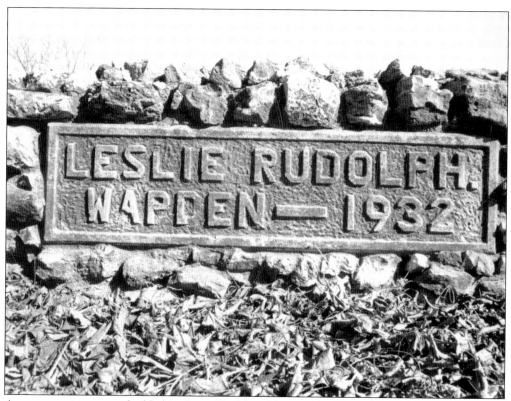

A stone carving was embedded in the wall of the old women's prison when that unit was located at the Missouri State Penitentiary. The plaque, dated 1932, indicates that Leslie Rudolph was the warden.

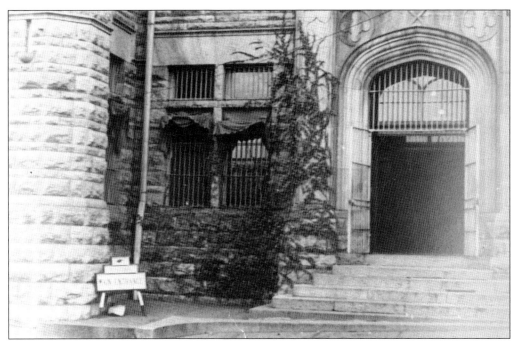

The old entrance to the
Missouri State Penitentiary,
west of the Control Center,
is pictured around 1906.

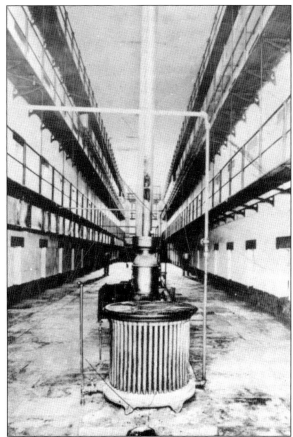

This stove, seen in the 1900s in one
of the housing units, provided heat
for the cell blocks. (Parks collection.)

The Missouri State Penitentiary Hospital is seen in a 1914 postcard. This four-story building served the medical needs of inmates, was equipped with an observation ward, operating rooms, and optical and dental departments, and served as the residence for elderly inmates. The third floor was dedicated to inmates with tuberculosis or mental issues. The prison morgue, laundry, kitchen, and officer's dining hall were in the basement of the building. This structure was torn down in 1938, and a hospital was included in the newly constructed Administration Building. (Parks collection.)

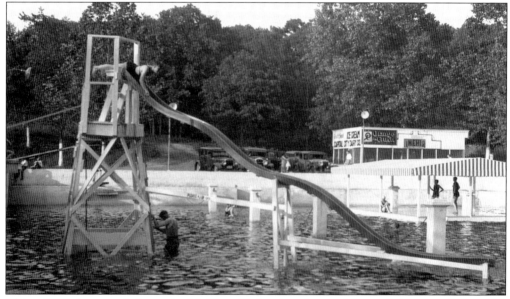

This c. 1930 photograph shows the McClung Park swimming pool, located about a mile from the Jefferson City prison. At that time, the park belonged to the Missouri State Penitentiary. Buildings on the grounds, including the pool and park site, were developed during the administration of warden O.C. McClung using inmate labor. For many years, this was the only swimming pool in Jefferson City. The city took over operation of the facility in 1940.

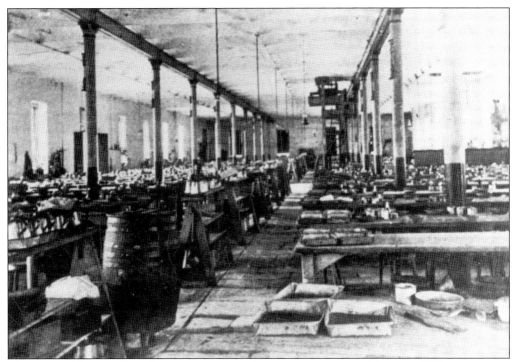

The former Missouri State Penitentiary main dining room is pictured here in 1889.

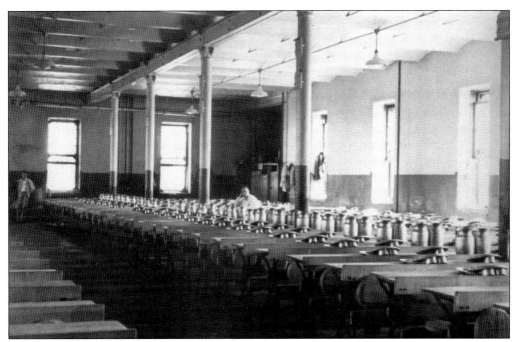

A c. 1915 photograph shows the interior of the old E Hall, where the 1954 prison riot started. The building was demolished in the 1960s.

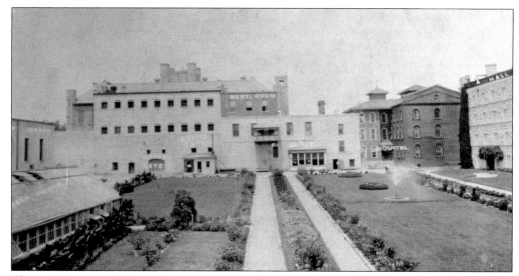

This c. 1908 postcard depicts the main courtyard with neatly planted flowers along the walkways. The buildings include, from left to right, (foreground) the greenhouse, wagon gate, round gate, Administration Building (women's unit), deputy warden's office, hospital, and Housing Unit 4/A Hall.

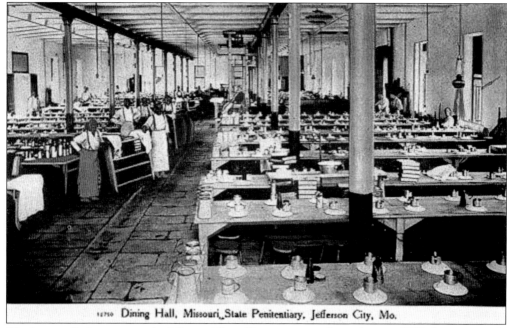

The inmate dining room at the Missouri State Penitentiary is shown here in 1889. Approximately 2,500 convicts were fed three meals per day in this hall. (Parks collection.)

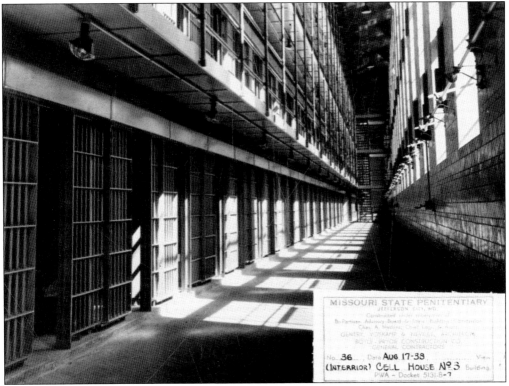

The inside of a Missouri State Penitentiary housing unit is seen on August 17, 1938.

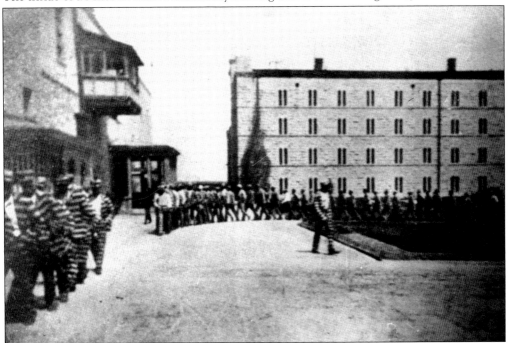

This photograph, taken sometime between 1900 and 1905, shows inmates dressed in striped uniforms marching on the prison grounds. The four-story building on the right is A Hall.

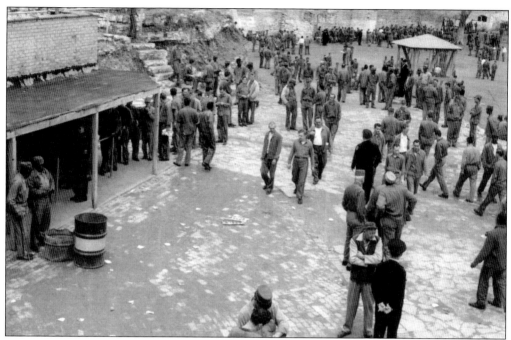

Inmates mingle during break time in the upper prison yard. The people in the black suits are prison guards.

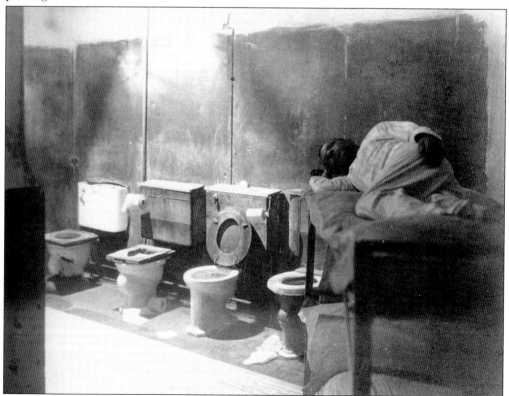

An inmate lies on the upper bunk in a toilet room in the A Hall cell block.

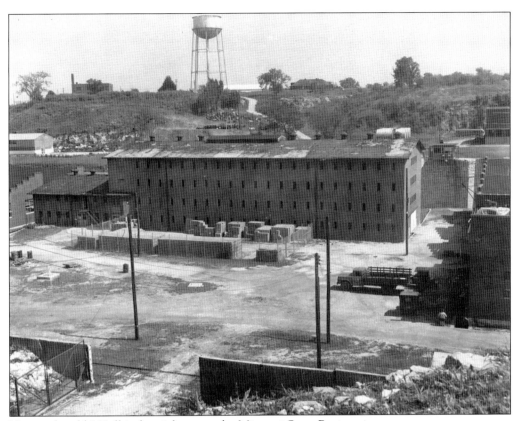

Here is the old I Hall industrial area at the Missouri State Penitentiary.

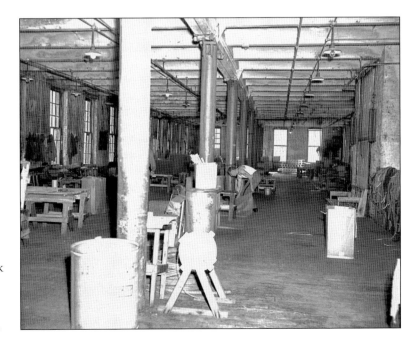

Inmates are at work in the Missouri State Penitentiary upholstery factory in this 1960 image.

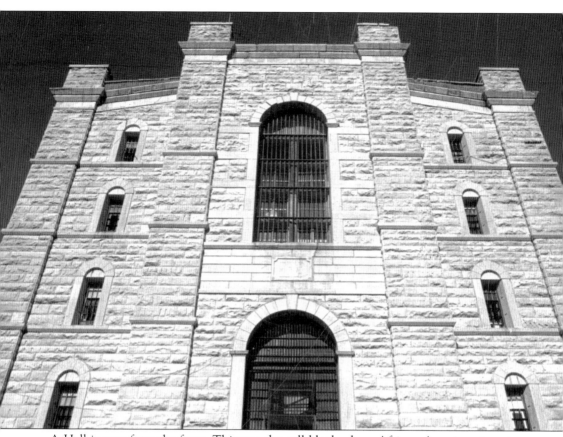

A Hall is seen from the front. This was the cell block where African American inmates were housed until the prison was integrated in the 1960s.

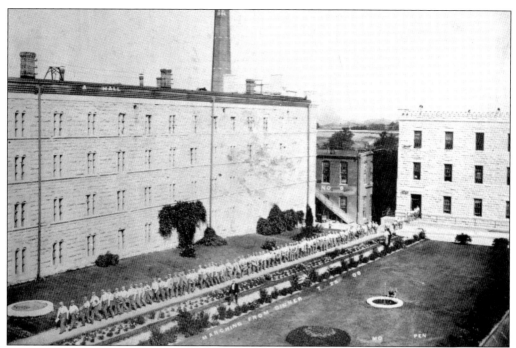

Seen on January 25, 1908, inmates wearing striped pants and white shirts march from the old D Hall dining hall on the sidewalk, which ran alongside A Hall, the tall white building on the left. Directly behind A Hall is the old maintenance building. Notice the tall smokestack from the power plant in the background. (Parks collection.)

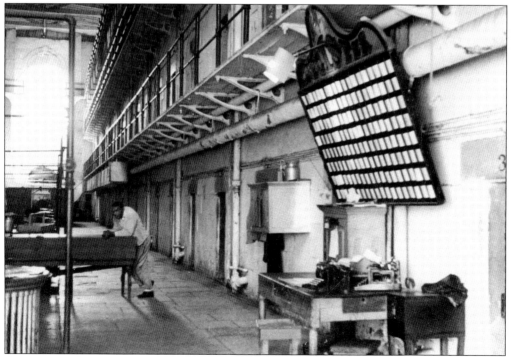

An inmate is leaning on a table in A Hall in this 1936 photograph.

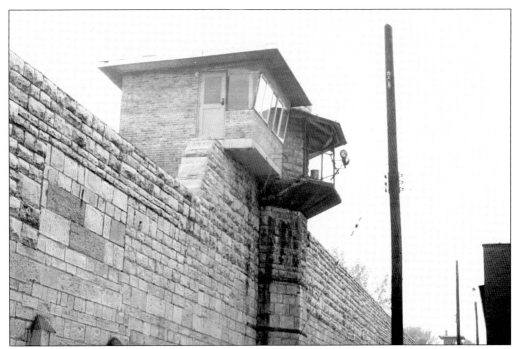

Old and new guard towers are situated side by side. The new tower (left) was a welcome addition, as the old towers were hot in summer and freezing in the winter.

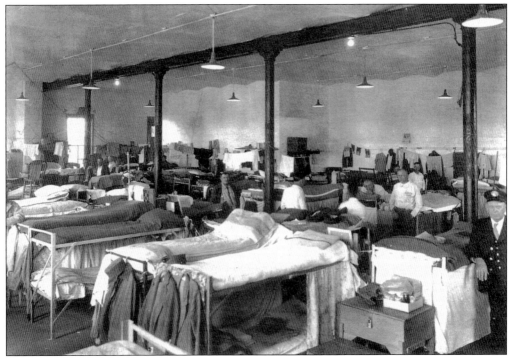

In this unidentified men's prison dormitory, bunk beds are placed close together, and inmates have hung their clothes at the foot of their beds. In the right foreground is a guard dressed in a uniform suit coat and cap along with a white shirt and tie. The inmates are seen in the background.

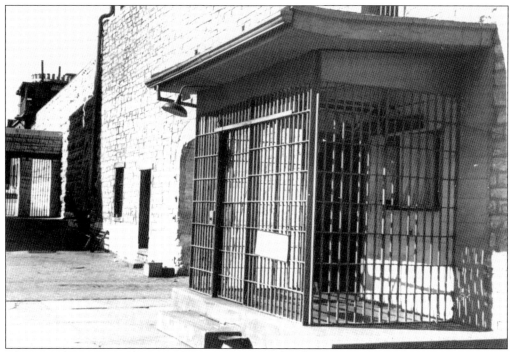

The caged area seen here is the entrance to the deputy warden's office in the Main Administration Building.

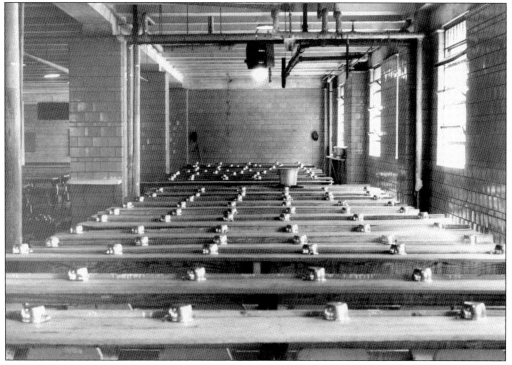

This 1957 photograph shows the old-style seating arrangement in a penitentiary dining hall with tin cups on the tables.

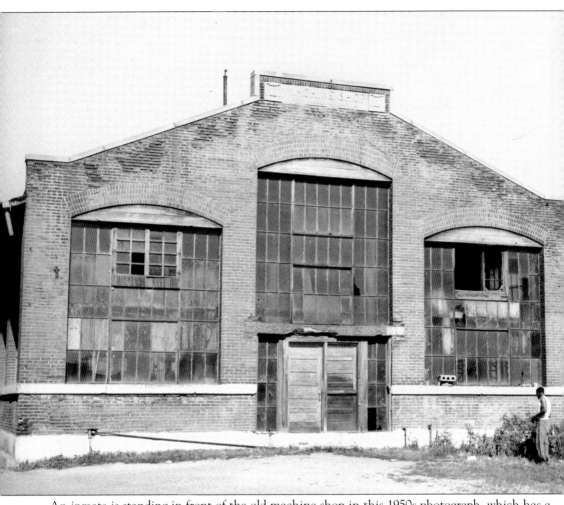

An inmate is standing in front of the old machine shop in this 1950s photograph, which has a stone engraving above the door inscribed, "Machine Shop/Henry Andrea Warden 1911."

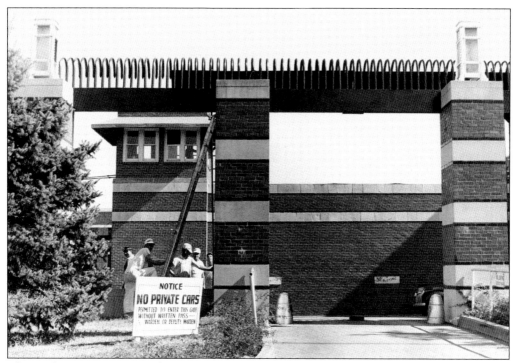

This is the garage entry to the penitentiary referred to as the L Hall gate, where new inmates entered. Inmates are working on a post on the left side. The sign in front reads, "Notice—no private cars permitted to enter this gate without written pass—warden or deputy warden."

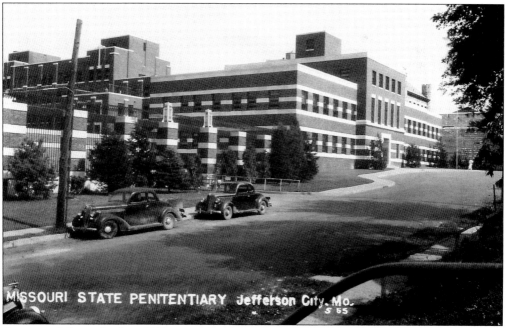

A postcard from the late 1930s or early 1940s shows the newly constructed Administration Building, which was the new entry to the penitentiary. Cars are parked on State Street in front of the building.

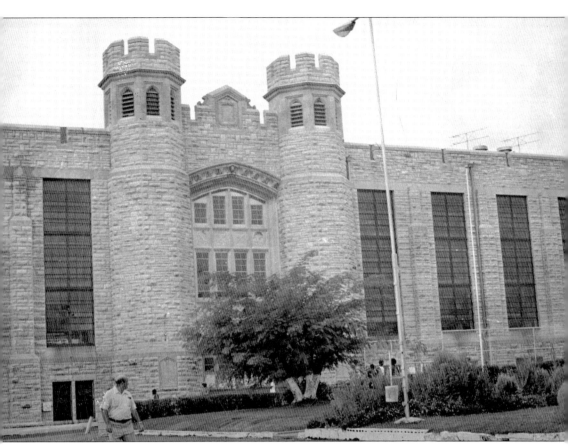

This is a photograph of the I Hall housing unit at the Missouri State Penitentiary, constructed in 1925. There are no other known structures predating I Hall at this location. The unit, which had three-man cells, was initially called B and C Hall but later was known as 3 A and B Hall. James Earl Ray, who assassinated Martin Luther King Jr., was an inmate here before escaping. The lower window on the far right was where Ray's cell was located. (Courtesy of Craig Sturdevant.)

Two

INMATES AND BUILDINGS BEHIND THE WALLS

There were a few buildings in the Missouri State Penitentiary that had an open, dormitory-room atmosphere where individuals had a bed, chair, and cabinet for personal items. Yet, others were not so hospitable. Before closing in 2004, many penitentiary buildings where inmates were housed were antiquated, in disrepair, and in most cases just slightly above the standard fit for human habitation. A prime example is A Hall, where inmates were still living the day the prison closed. Constructed in 1868 by inmate labor with stone quarried on-site, A Hall was structurally sound on the exterior but in deplorable condition on the interior. The cells were small, and at one time each held four or six inmates in a space barely fit for two. Certainly, the four-tier building would not have been adequate for an inmate with a moderate handicap. This housing unit had an unsanitary shower area, toilets that had to be elevated in order to keep them from flooding the cell, and a dungeon area known as The Hole.

The old buildings had places where ingenious inmates could hide for extended periods. There are hundreds of stories of prisoners concealing themselves behind the walls. One case involved inmate James Earl Ray, who was known to hide out for extended periods over his seven-year prison term. Ray, after escaping from the penitentiary, was later convicted of killing Dr. Martin Luther King Jr. in Memphis, Tennessee. A second notable instance occurred in October 2003, when an inmate named Toby Viles was murdered by two offenders who worked with him in the prison's ice plant. The two murderers were found four days later in a room that the inmates had prepared for an extended stay. It was concealed from corrections staff until they began to punch holes in pegboards that covered the walls. The offenders were planning to wait until the closure of the Missouri State Penitentiary to escape. They were only off by about 11 months.

One of the unique living arrangements at the Missouri State Penitentiary was the area that housed death-row inmates. Until April 1989, when Missouri's death row was moved to the Potosi Correctional Center, the unit was located at the Missouri State Penitentiary. When it was in Jefferson City, people awaiting execution were housed in an underground area in isolation from other inmates. All services were provided to that unit, and inmates did not leave their self-contained facility except for one hour of exercise per day in an adjacent fenced-in area. After a legal challenge, the Missouri Department of Corrections made a change to stringent death-row isolation, including the establishment of an internal classification system with privileges awarded for behavioral changes. A "privacy room" was provided for death-row inmates to attend religious services.

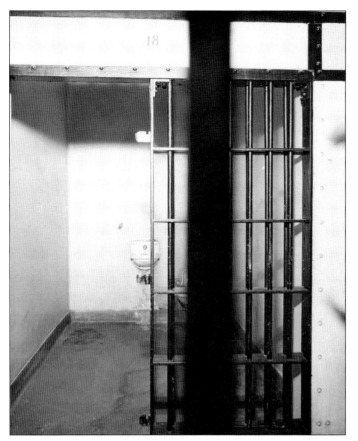

This cell has a sink directly facing the entrance to the cell. To the right of the sink, and partly hidden by the cell bars, is a toilet bowl. Obviously, life was tough behind the walls of the prison.

With conditions a bit different from the convict-labor era of the early years, inmates work on a paving project in the 1970s.

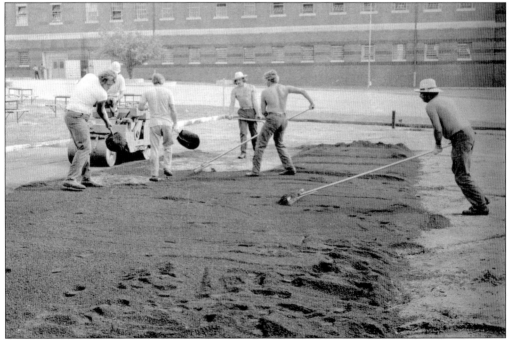

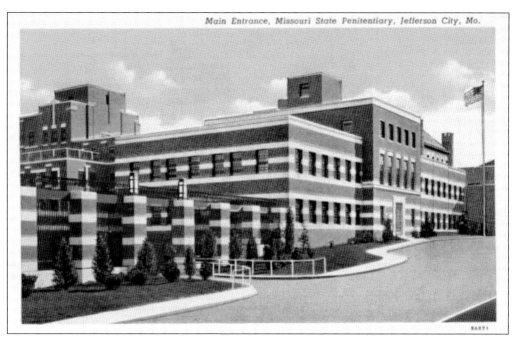

Most people familiar with photographs of the Missouri State Penitentiary recognize the institution by the modern Administration Building, added in 1939 to the front of the Gothic-style main entrance and administrative center. This new facade served for more than 70 years as the entrance to the prison complex and totally hid the original building. (Parks collection.)

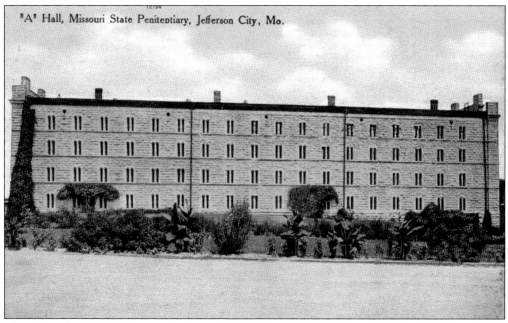

"A" Hall, Missouri State Penitentiary, Jefferson City, Mo.

This is a side view of A Hall. The four-story building was the oldest structure on the prison compound when the penitentiary closed in 2004. (Parks collection.)

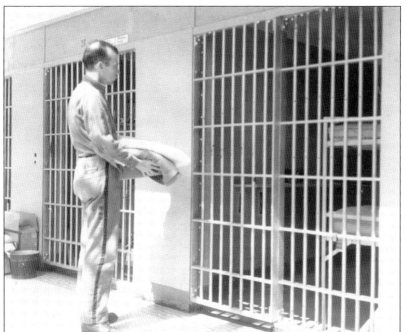

An inmate looks a little unsure of himself after being newly assigned a cell.

The main prison is pictured in 1954 following a prison riot. The photograph does not show the extensive damage in the courtyard done during the upheaval.

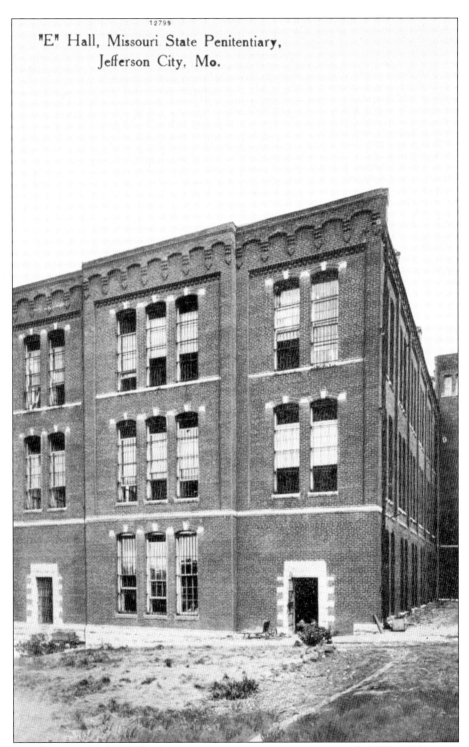

"E" Hall, Missouri State Penitentiary, Jefferson City, Mo.

This is a photograph of E Hall, where maximum-security inmates resided. The 1954 prison riot started here and spread to the rest of the prison. The building was extensively damaged during the riot and is no longer standing. (Parks collection.)

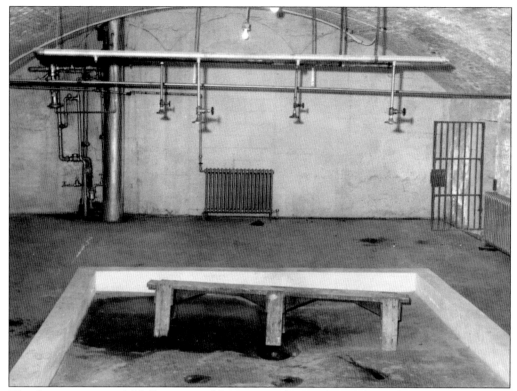

The shower room in A Hall is pictured here. From the number of showerheads, it appears that four to five inmates could shower at the same time. The sanitary conditions of this area probably would not be suitable by current standards.

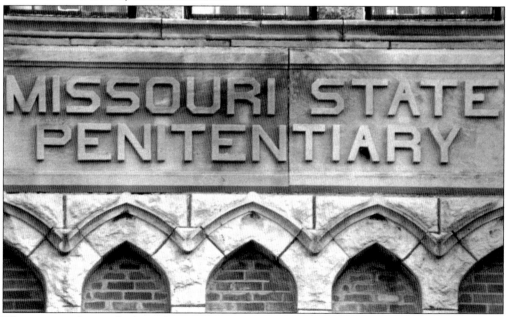

This stone etching, which reads, "Missouri State Penitentiary," is seen on the entrance to the old Administration Building.

Guard Tower 10 overlooks the prison grounds. This 1991 photograph represents one of the newer, renovated guard towers. The penitentiary had 16 guard towers in all. Staffing the towers on a round-the-clock basis was an expensive proposition. Each tower had one guard for every eight-hour shift (three guards per day); however, from a manpower perspective, the prison administration had to factor in a substitute guard for each tower necessitated by vacations, sick leave, or guard training.

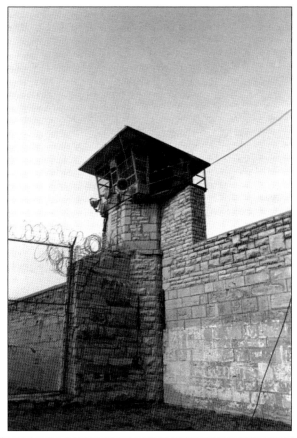

The main-gate garage area shows inmates either painting or performing repairs on one of the pillars in 1951.

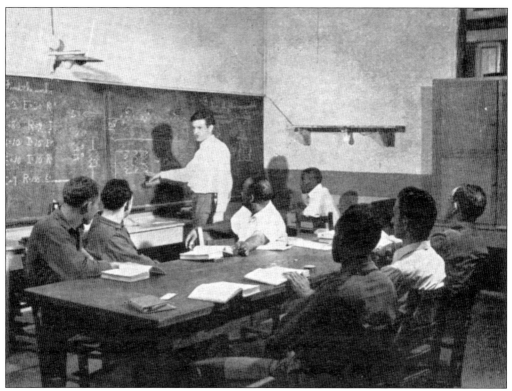

This is a photograph of a Missouri State Penitentiary class in radio theory from the 1947 annual report of the institution. Many inmates attended school after work hours, with fellow inmates serving as instructors. It should be noted from this photograph that while the class was integrated in the 1940s, inmates nevertheless resided in segregated housing units.

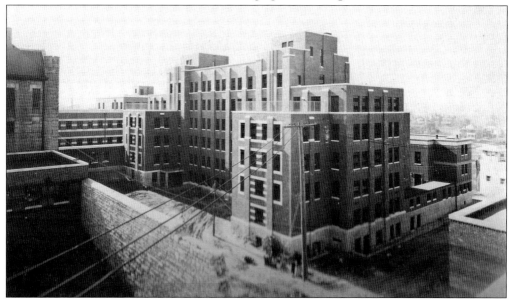

This is the rear of the newly constructed hospital and tuberculosis dormitory that was built in 1939 at a cost of $436,000. (Courtesy of Mark Schreiber.)

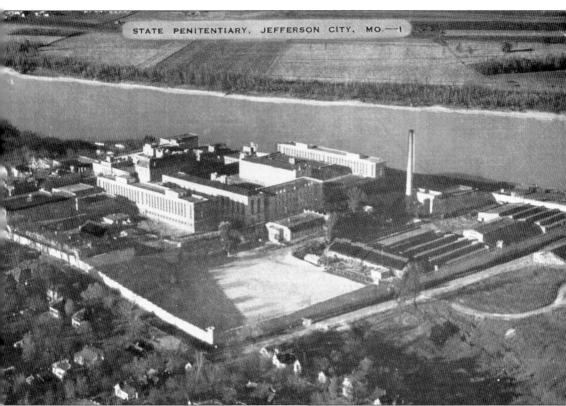

An aerial view of the Missouri State Penitentiary grounds shows the proximity of the institution to the Missouri River. Evident in the lower left is the white stone wall that surrounds the prison grounds.

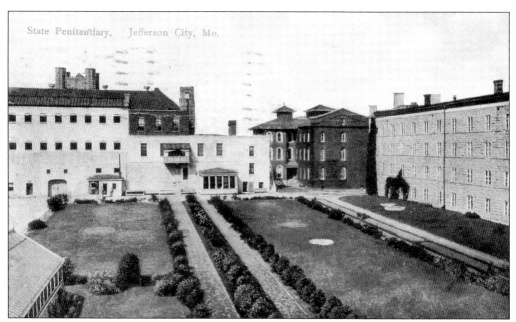

State Penitentiary, Jefferson City, Mo.

A courtyard view shows neatly planted flowers and a greenhouse on the far left. The dark building in the right center is the prison hospital, with A Hall to the right of it.

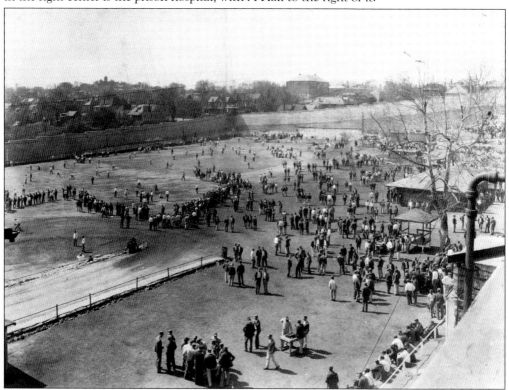

Inmates mingle in the lower prison recreation yard that had a ball field, weight-lifting area, and basketball court. The yard was formerly a rock quarry where rock was obtained for many buildings and the fence that surrounds the penitentiary site.

STATE PENITENTIARY
Jefferson City, Missouri

TROOPER R. G. BREID

Your presence is requested at the execution of Floyd Cochran within the walls of the Missouri State Penitentiary at Jefferson City, at 12:01 a.m., on Friday,

SEP 2 6 1947 NOT TRANSFERABLE

Warden

Please advise promptly if unable to attend.

This card admitted a person to a 1947 inmate execution. Executions took place at the Missouri State Penitentiary until April 1989, when the state transferred the 70 people on death row at the time to the Potosi Correctional Center.

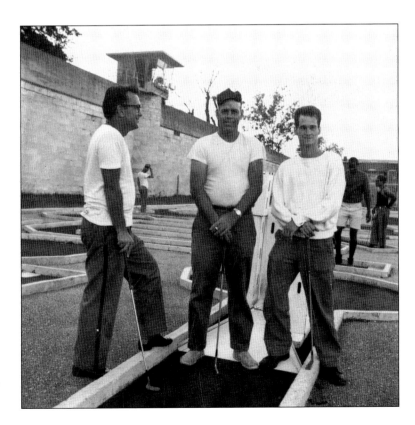

Three inmates play miniature golf during the 1960s.

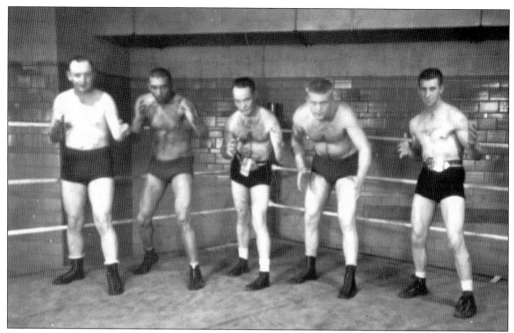

For recreation, there were various intramural sports prisoners could participate in, including the inmate wrestling team, shown here in the 1950s.

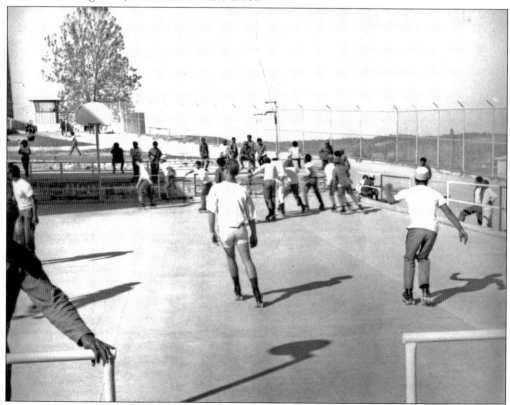

Inmates are skating in one of the recreation courtyards.

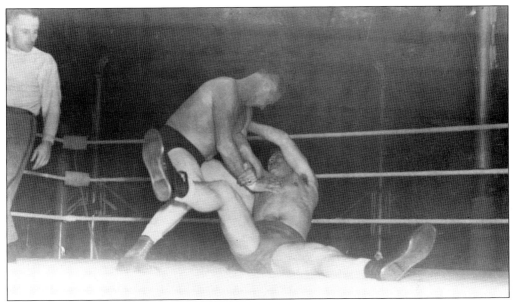

Inmate wrestlers are participating in an event about 1959. The man on the far left with a stripe on his pants is the referee.

Warden Donald Wyrick (left) is pitching horseshoes with an inmate in the upper yard in 1975. The warden began his employment at the penitentiary as a prison guard (now called "corrections officer") and rose up through the ranks in 15 years to lead the institution. His tenure at the penitentiary was during the most troubled time in the history of the prison.

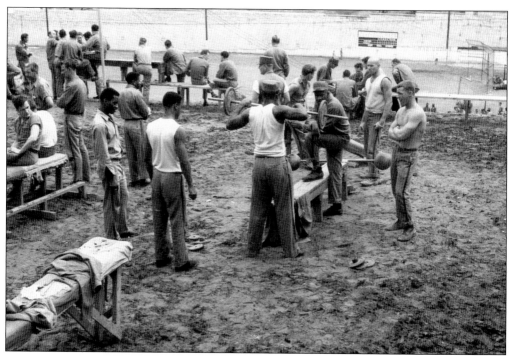

Inmates kill some time in a workout area in the lower prison yard in the 1950s.

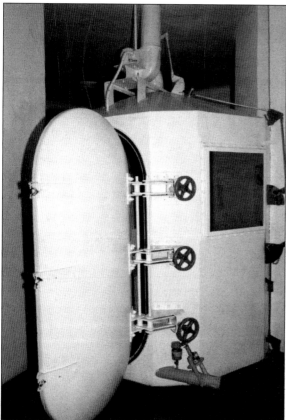

The Missouri State Penitentiary gas chamber is pictured in the 1960s or 1970s. The chamber, located in a small rock building set apart from the main prison, was constructed in 1937 at a cost of $3,570. The structure housed two small cells on one side of the room and the gas chamber on the other side.

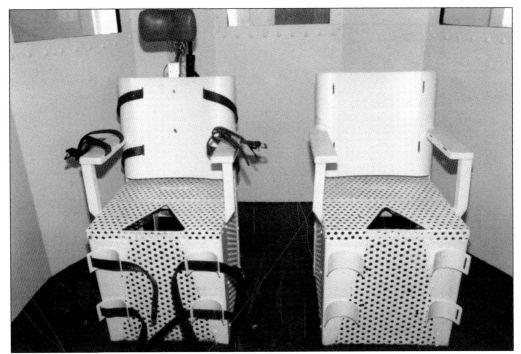

The gas chamber building had two cells, one of which was reserved for the condemned person the last few hours before execution. The second cell was used for mixing sulfuric acid used in the execution. Also, this cell contained the crocks used to hold the sulfuric acid that was later placed under the perforated chair, and the leather restraints held the condemned person in the chair.

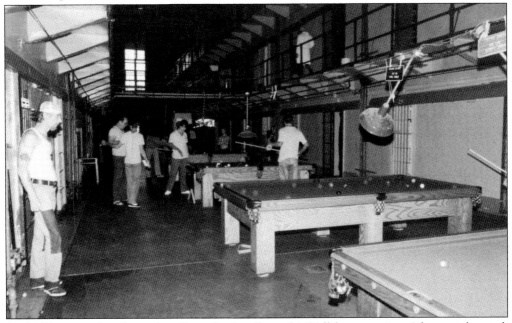

Pool tables were placed outside cells on the first floor of A Hall for recreation. After a trial period, though, the tables had to be removed because inmates used the balls as weapons in fights with other inmates.

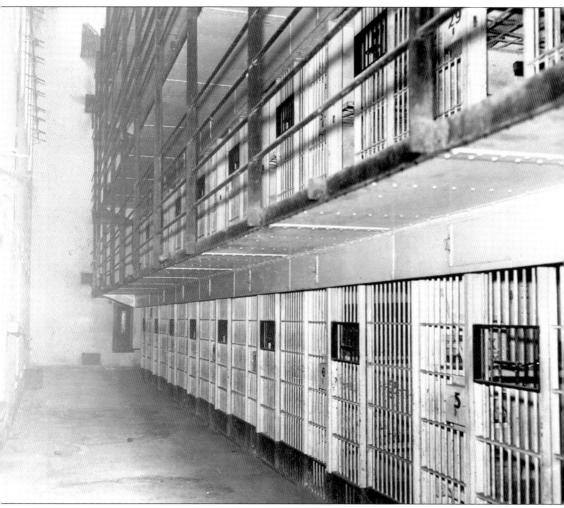

Pictured here are cells in the F and G Halls. This housing unit was similar to J Hall, which was built about the same time.

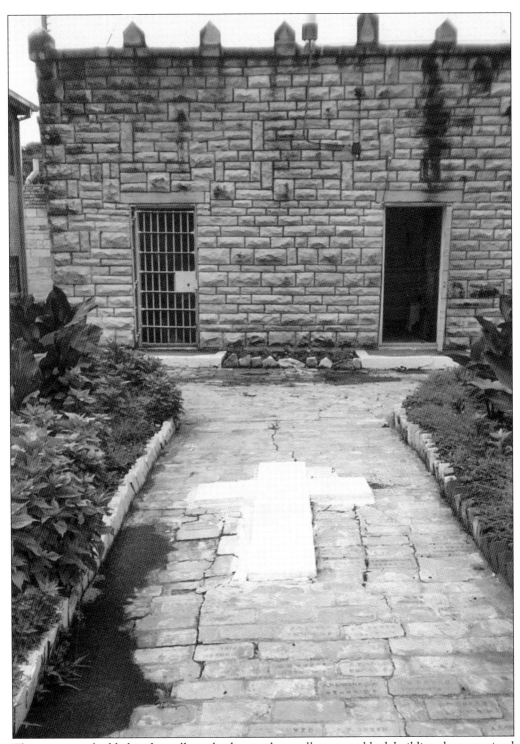

This cross is embedded in the walkway leading to the small concrete block building that contained the two gas chamber chairs. After execution, the lethal gas was extracted from the chamber and vented out of the building through a 45-foot pipe.

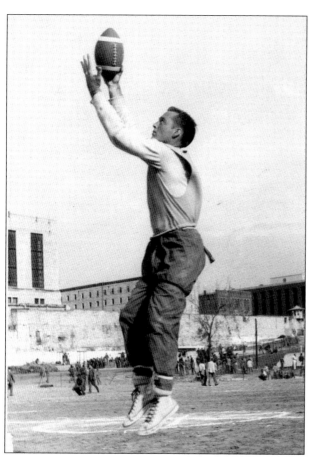

An inmate is playing football in the prison yard.

Inmates mingle during a recreation break in the upper-yard recreational area at the penitentiary. The former Warden's residence, which was outside prison grounds at 700 East Capitol Avenue, is seen in the background.

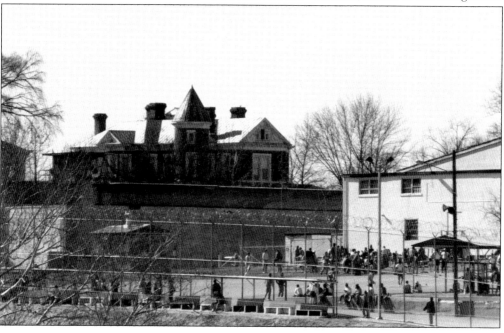

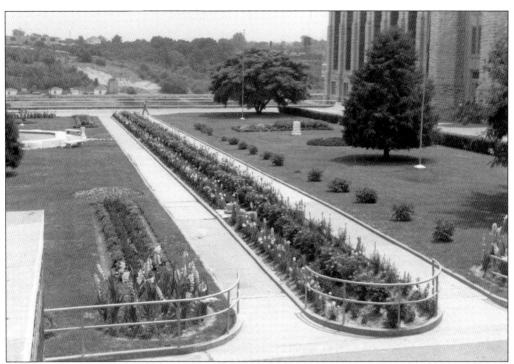

The neatly landscaped upper prison yard is seen in a 1955 photograph, with a fountain in the upper left. Before this, the area contained several buildings constructed in the early days of the prison. In the upper right is 3 A and B Hall. In front of this building was where the former prison greenhouse stood, and in the lower right-hand corner was home to the old tailor shop at one point.

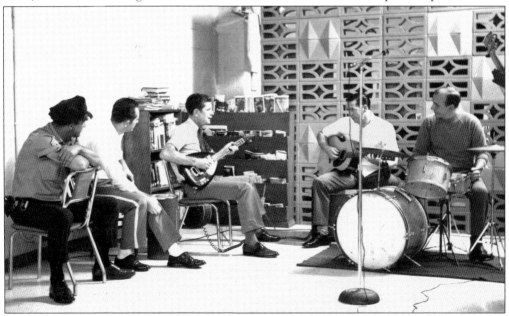

An inmate band is pictured in 1960, with Warden Donald Wyrick in the center playing guitar. It should be noted that Wyrick was the youngest-appointed warden, had the longest tenure as head of the institution, and was the last "official" warden of the Missouri State Penitentiary.

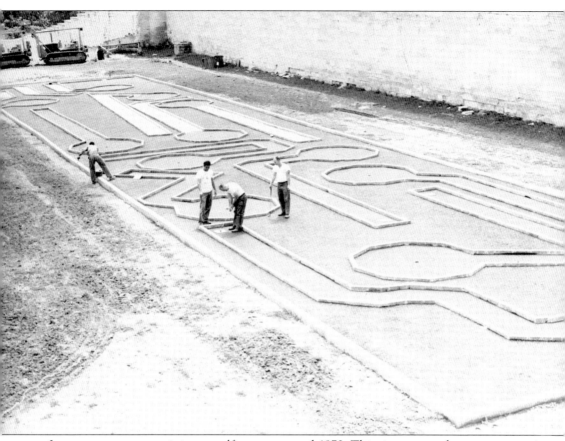

Inmates construct a miniature golf course around 1970. This site was on the upper recreation yard. On the far left, a hillside drops off to the lower recreation yard.

An inmate checks out an item at the clothing commissary.

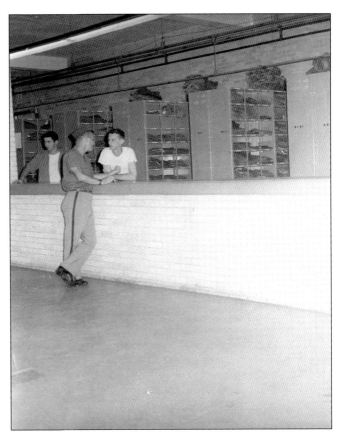

Inmates play handball on the court. There is a guard tower in the upper left where a prison guard observes activity in the yard.

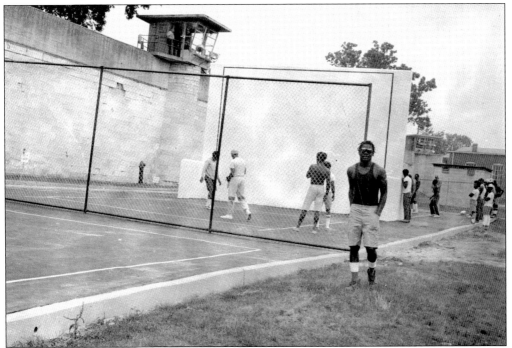

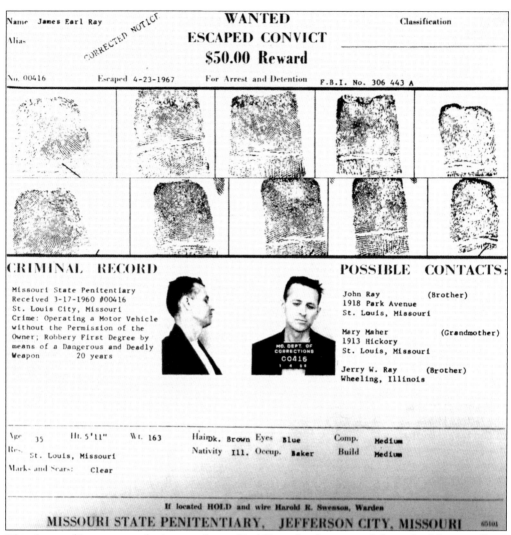

This "wanted" poster was for inmate James Earl Ray after he escaped from the Missouri State Penitentiary in 1967. A $50 reward was offered for information leading to his capture. Ray was later convicted of the 1968 murder of Dr. Martin Luther King Jr. in Memphis, Tennessee, and died in a Tennessee prison some years after a failed escape attempt from that facility.

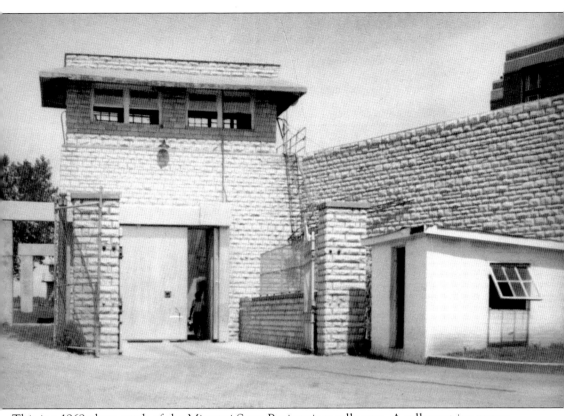

This is a 1969 photograph of the Missouri State Penitentiary sally port. A sally port is a secure, protected entrance for places such as prisons and defensive structures.

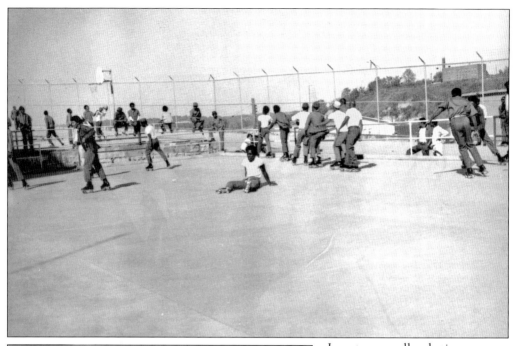

Inmates are roller-skating in the lower prison yard.

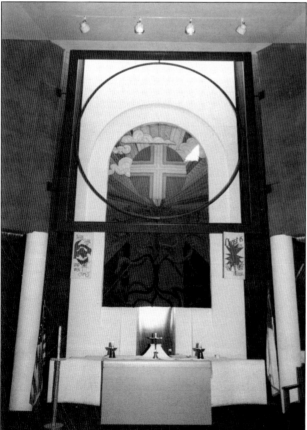

This is a 1986 photograph of the altar in the chapel, which was constructed after the 1954 riot destroyed the building where the former chapel was located. The chapel pictured was demolished after the prison closed because Missouri officials did not believe that the building had historical significance, nor was it appropriate for other uses in the prison redevelopment program.

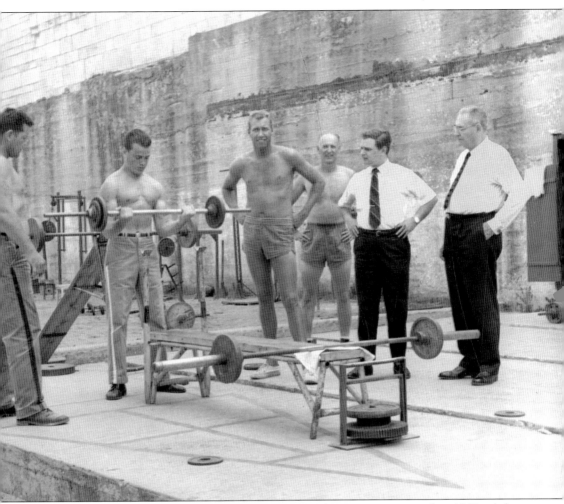

Three inmates are engaged in a bodybuilding exercise in the upper prison yard in 1968, while two prison officials interact with them during the workout session.

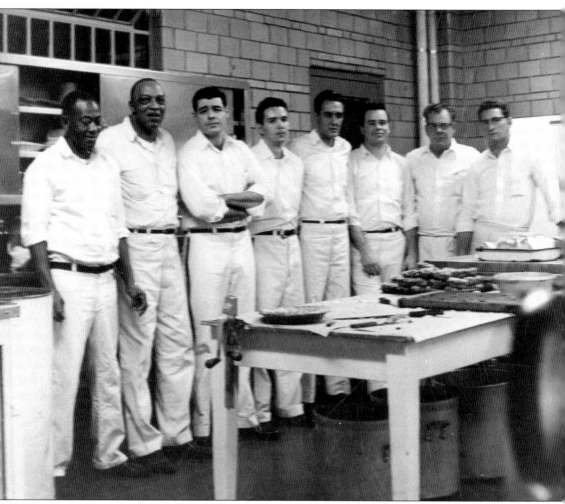

Inmate workers in the officer's dining room pose for this photograph. All penitentiary staff could take advantage of free meals and were given the same food as inmates. This procedure eliminated complaints from prisoners about poor food since staff ate the same dishes.

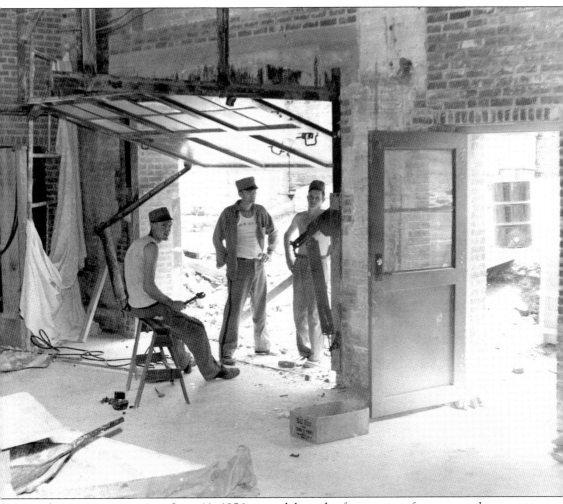

Several inmates are seen on June 11, 1956, remodeling the former soap factory warehouse, which became fully operational in 1957, producing well over a million pounds of soap products per year.

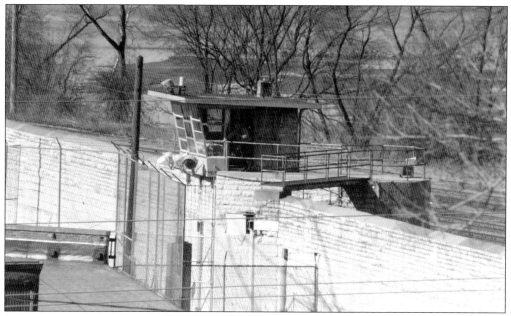

One of the newly built guard towers, located in the rear of the prison property, had a catwalk for observational purposes.

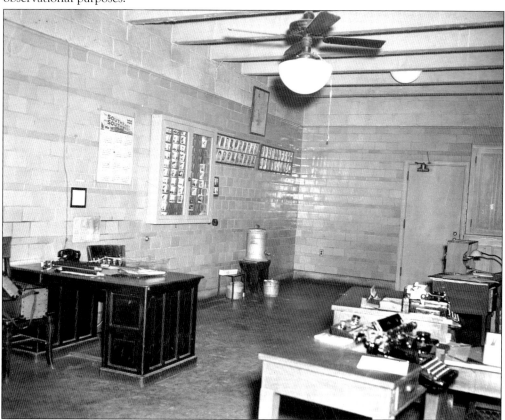

A counseling office was located in the administrative area of the Administration Building.

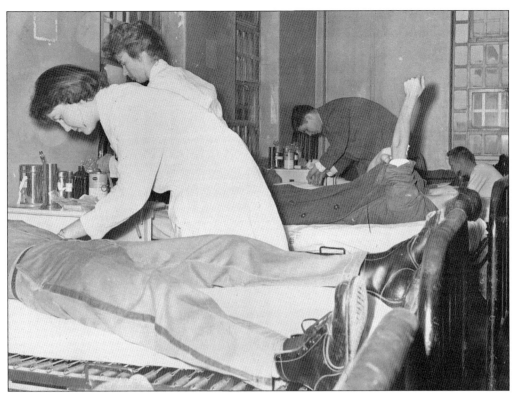

Two nurses care for a patient, who looks to be a guard from his attire, in the prison hospital.

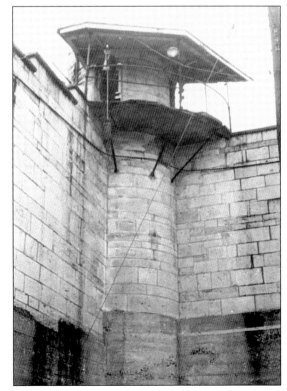

One of the old guard towers is pictured before the observation towers were remodeled. A prison guard stands outside the tower looking down on the yard.

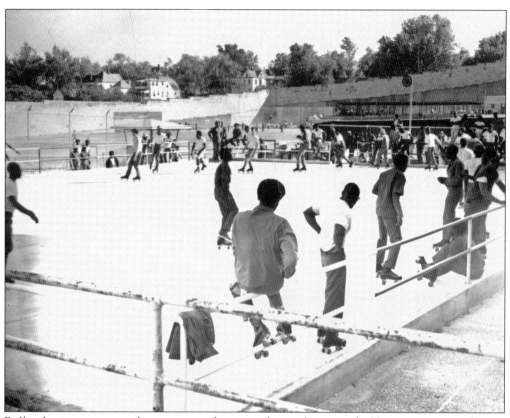

Roller-skating was a popular recreational activity during free periods. Here, inmates are skating in the area designated for recreation.

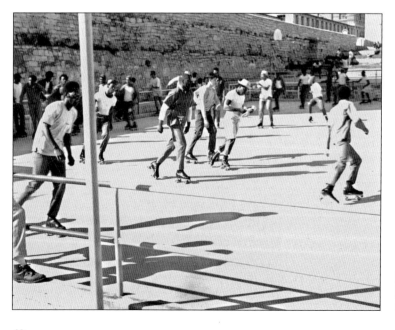

Inmates are skating in one of the recreation courtyards.

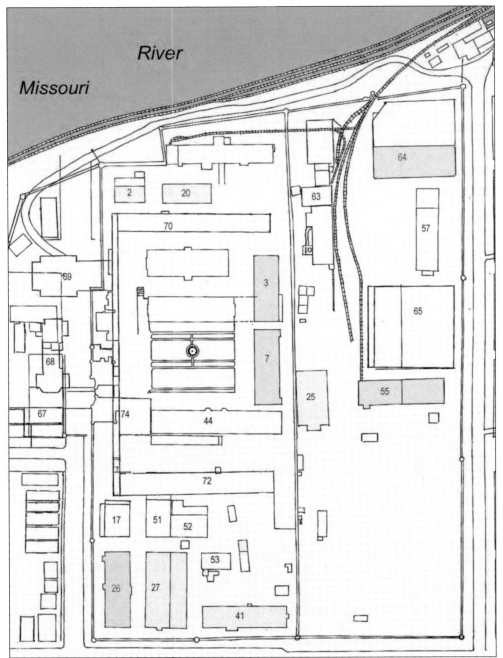

This 1955 footprint of the Missouri State Penitentiary following the 1954 prison riot shows that the burned buildings on this sketch were numbers 64 (shoe factory), 3 (Jefferson & Standard Shoe Company), 7 (dining hall), 55 (auto tag plant), and 26 (Priesmeyer Shoe Company). The burned buildings that were rebuilt included 2 (Jacob Strauss Saddle and Tannery), 20 (machine shop), 25 (auditorium), 27 (Geisecke Shoe Company), and 41 (shirt factory). Others buildings on the sketch are 70 (O Hall), 69 (storage/kitchen), 68 (hospital), 67 (Administration Building), 72 (cell block), 17 (J.S. Sullivan Saddle Tree Factory), 51 (storage/cutting/print shop), 52 (produce warehouse), 20 (machine Shop), and 53 (box factory). (Courtesy of Craig Sturdevant.)

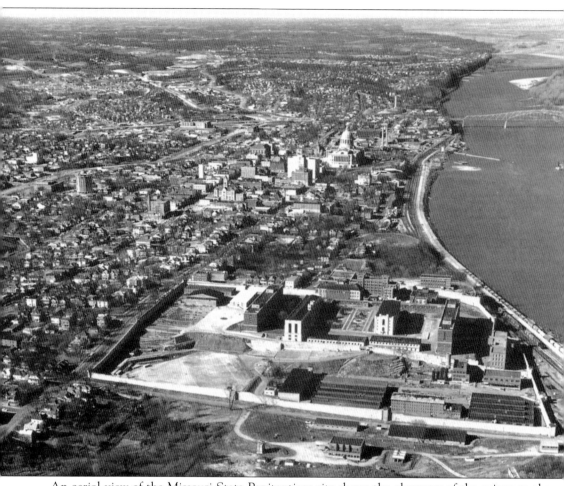

An aerial view of the Missouri State Penitentiary site shows the closeness of the prison to the Missouri River.

The prison chapel, shown here, was constructed after the 1954 riot in the courtyard area. The tall extension at the rear of the building housed the altar. A Hall is to the right of the chapel.

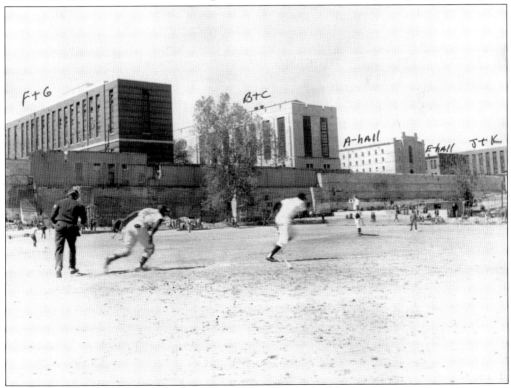

An inmate baseball game is taking place on the playing field located on the lower prison yard property. Various halls for prison housing are labeled.

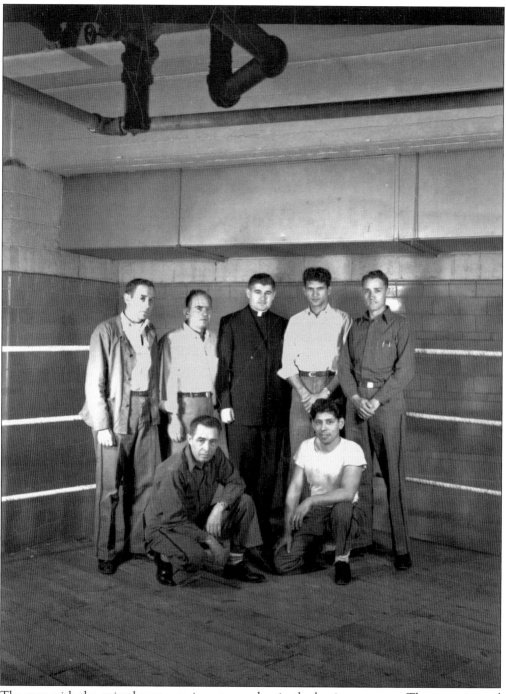

The men with the striped pants are inmate coaches in the boxing program. They are pictured with a priest who was a supporter of the program.

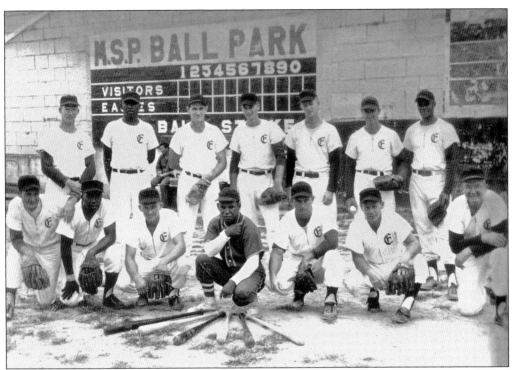

Members of a baseball team pose for this photograph in front of the "MSP Ball Park" sign and the park scoreboard. This was probably not an inmate team since the players do not have on dark pants, which was the usual attire. Frequently, teams were recruited from outside the penitentiary to compete against an inmate team. The Jefferson City Parks and Recreation Department supplied many of the off-site squads.

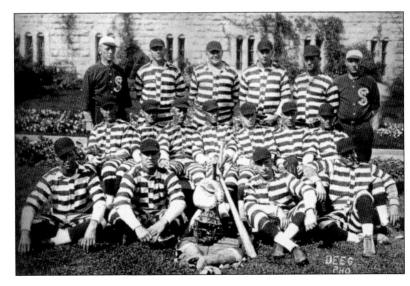

This 1920s photograph of the Missouri State Penitentiary baseball team was taken next to Housing Unit 4/A Hall. (Courtesy of Mark Schreiber.)

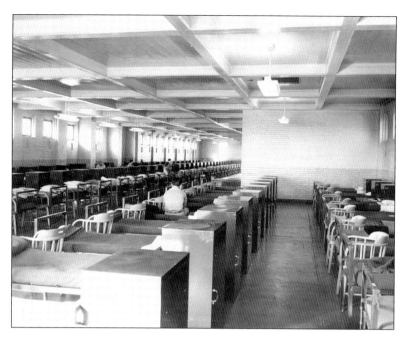

With dormitory-style living arrangements, each inmate of the unit had an individually assigned bed along with a cabinet for personal items and a chair. The room appears well lit, and an inmate is sitting on one of the beds.

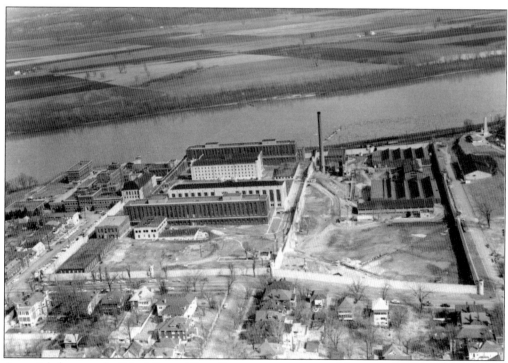

An aerial photograph of the Missouri State Penitentiary compound shows the Missouri River, which runs near one of the four prison walls. In the center is a wall that divides the upper prison grounds on the left and the lower prison grounds on the right. (Courtesy Dottie Summers Dallmeyer.)

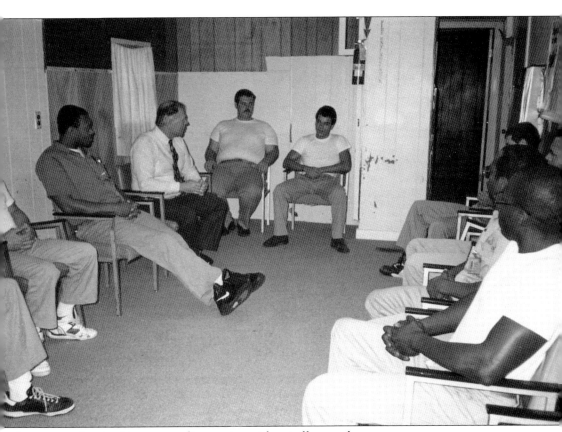

Inmates are involved in a counseling session with a staff counselor.

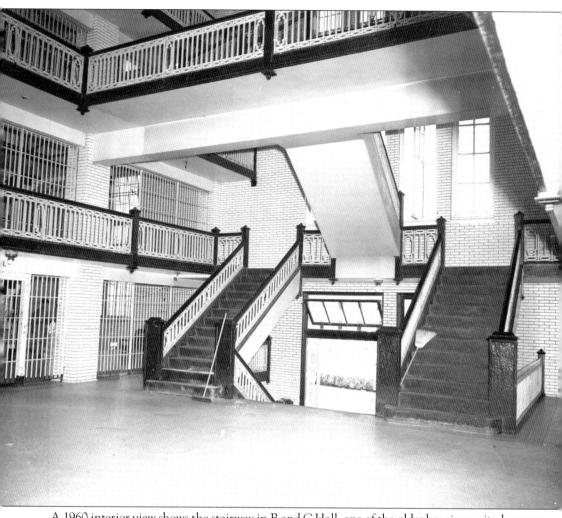

A 1960 interior view shows the stairway in B and C Hall, one of the older housing units; however, its construction made it one of the better housing sections. Inmates in this unit barricaded themselves in during the riot of September 1954.

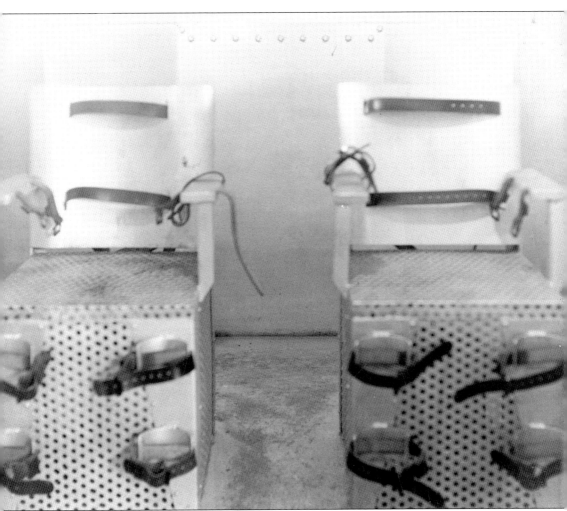

The two chairs in the gas chamber are pictured from ground level. A total of 39 inmates were executed in the Missouri State Penitentiary from March 4, 1938, to February 26, 1965, the date of the last execution at the prison. Of that number, 30 were executed for murder in the first degree, six for rape, and three for kidnapping. Carl Austin Hall and Bonnie Brown Heady were executed side by side for the kidnapping and murder of a six-year-old boy on December 18, 1953. Heady was the only woman executed by lethal gas at the Missouri State Penitentiary.

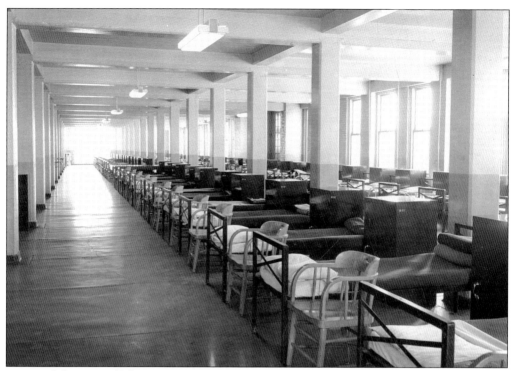

A second floor C Hall dorm room is pictured in 1957.

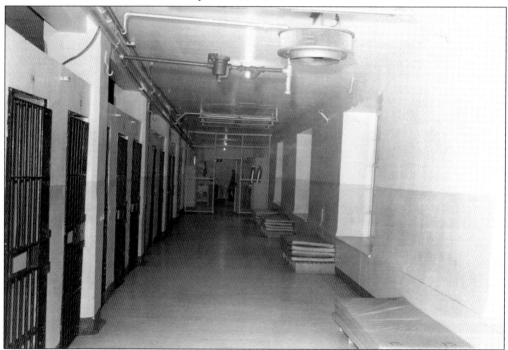

The O Hall punishment unit is seen in 1970. This was a segregation unit for persons who had violated a prison rule. The inmate admitted usually received a 10-day assignment to the unit and during that time was only allowed outside his cell for a shower.

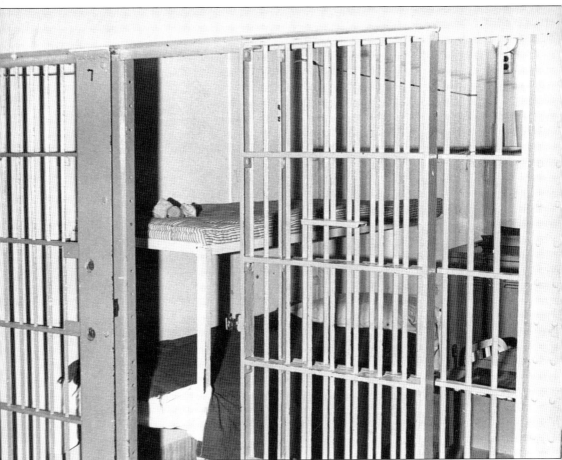

This 1955 photograph shows a typical cell in H Hall, which was the diagnostic unit in the institution. Each cell contained an upper and lower bunk bed. On the back wall of each cell was a light fixture and a two-prong electrical outlet.

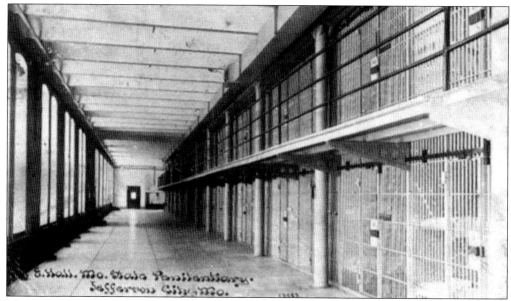

This is inside of E Hall, which was one of the older residential housing units of the Missouri State Penitentiary compound. Inmates residing in this hall started the 1954 prison riot and extensively damaged the building by setting fire to it. Following that upheaval, the building was considered uninhabitable and was later torn down.

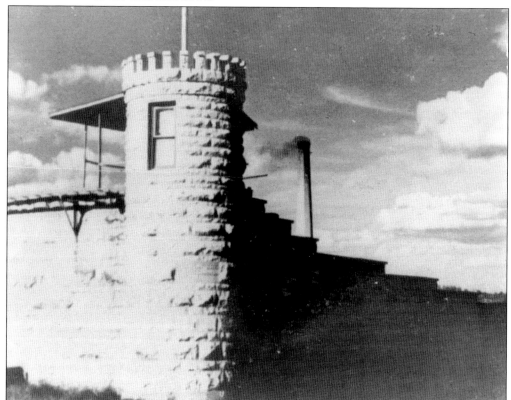

An old, turret-style guard tower was used before new towers were constructed.

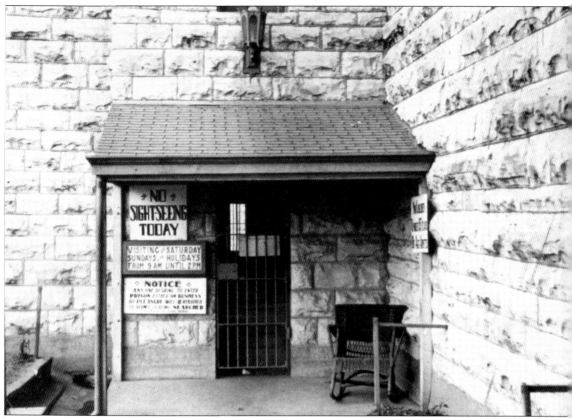

This is the entry door for visitors to the prison. Under the "No Sightseeing Today" sign is one that reads, "Visiting on Saturday, Sundays and Holidays From 9 am until 2 pm."

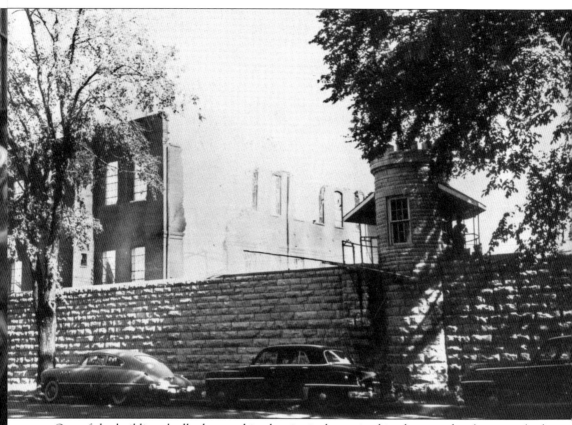

One of the buildings badly damaged in the riot is shown in this photograph taken outside the prison walls.

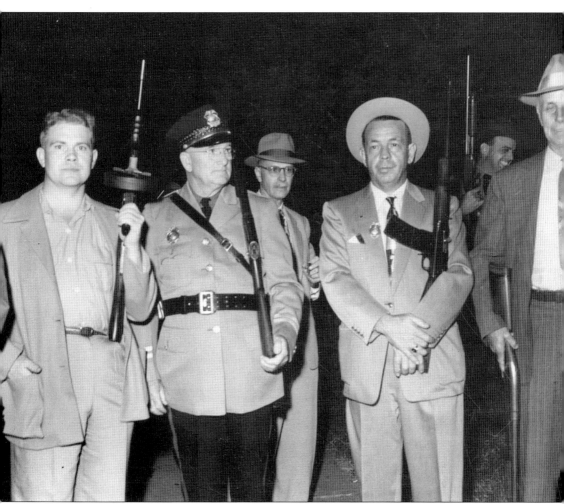

These law enforcement officers are pictured during the prison riot. The man second to the right, dressed in the suit with the gun on his shoulder, is Cole County sheriff Ben Markway.

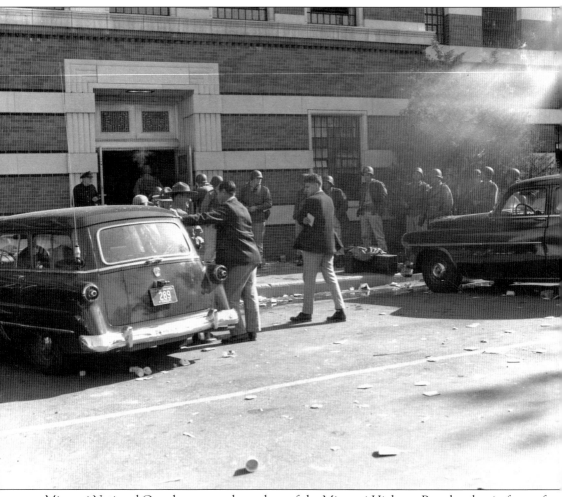

Missouri National Guard troops and members of the Missouri Highway Patrol gather in front of the Administration Building the day following the 1954 prison riot.

Lt. Gov. James T. Blair, with a pistol in the holster on his right hip, is seen in the Control Center lobby during the riot.

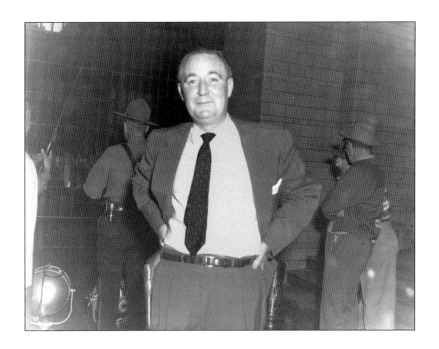

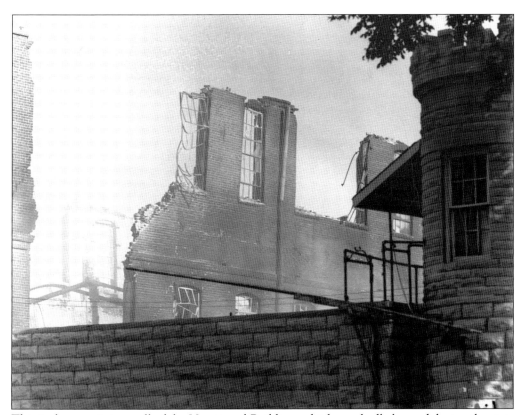

This is the remaining wall of the Vocational Building, which was badly burned during the riot.

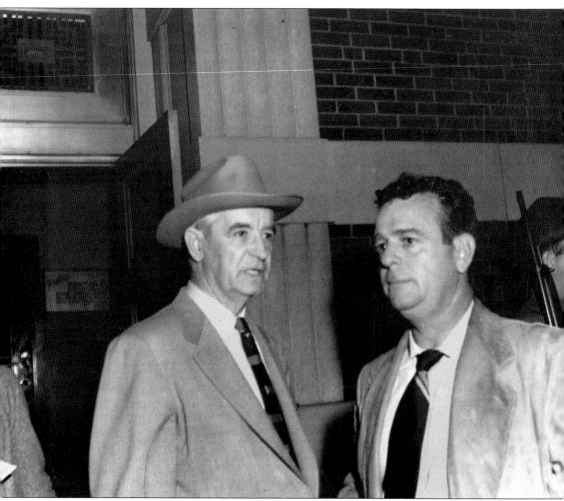

Missouri governor Phil M. Donnelly (left) and Col. Hugh Waggoner, head of the Missouri Highway Patrol, are pictured in front of the Administration Building during the upheaval.

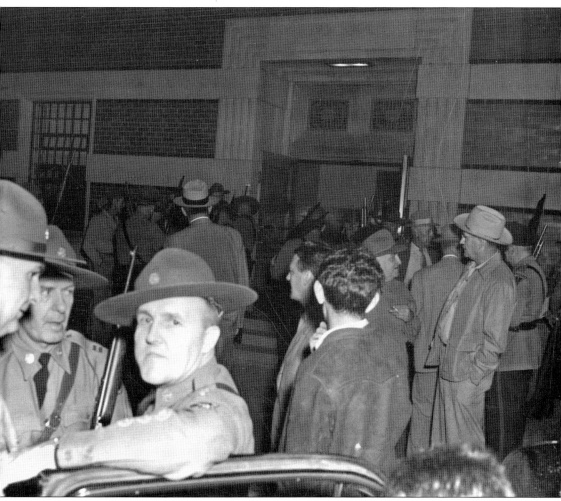

Missouri state officials visit the riot site. Pictured here are Maj. (later Col.) Mike Hockaday facing the camera; standing next to him on the far left is Capt. (later Maj.) Marion Parker, and on the far right is W.C. Parker, a Missouri Department of Corrections warrant officer, with his hands in his pocket and wearing a Western-style hat.

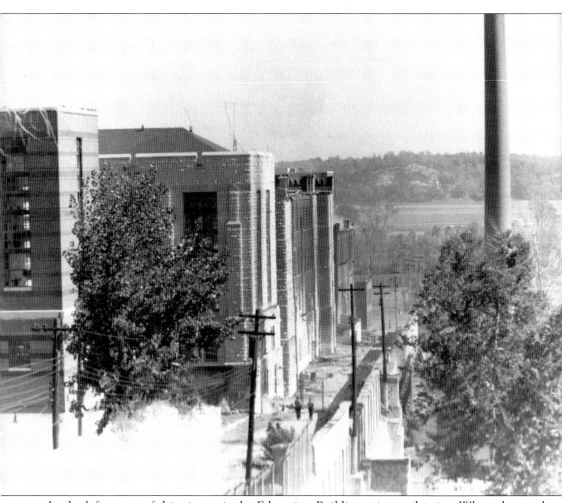

In the left center of this picture is the Education Building prior to the riot. When the revolt started, two staff members trapped inside hid in a housing unit on the ground floor. Luckily, they were able to escape when the riot subsided by using a car axle to open a window.

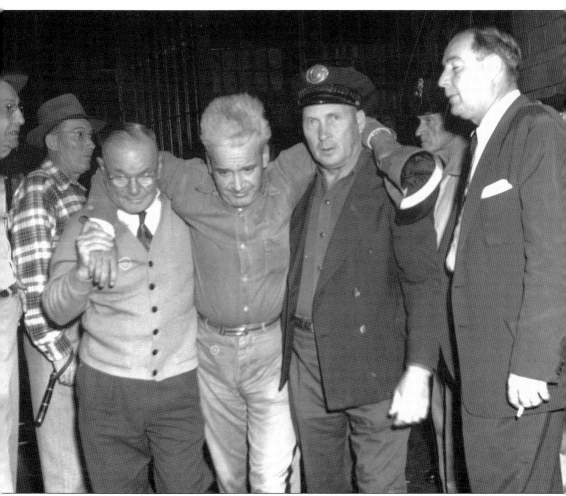

Corrections staff assist an injured inmate to safety. The man on the far right is Missouri lieutenant governor James T. Blair.

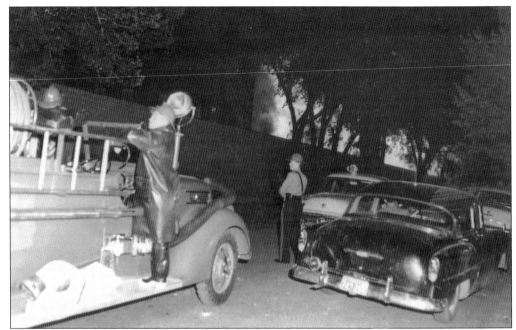

Firemen and police officials converge outside the prison walls at the 700 block of East Capitol Avenue and watch the fire burn on September 22, 1954. These people deemed it too dangerous to enter the prison because the inmates were not contained and could escape through the gates. (Courtesy of the Mark Schreiber collection/Missouri State Archives.)

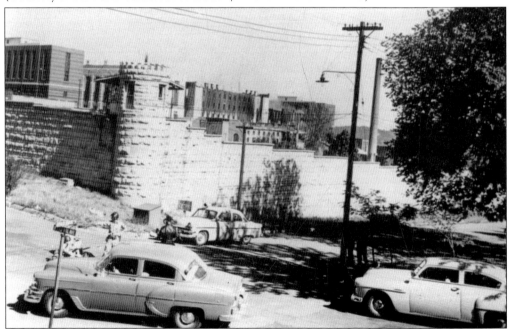

Missouri National Guard troops direct traffic at the corner of East Capitol Avenue and Chestnut Street the day after the 1954 riot. Note the damage to prison buildings. In the rush to come to Jefferson City from across the state in order to provide assistance, some Missouri Highway Patrol units ruined their car engines due to overheating.

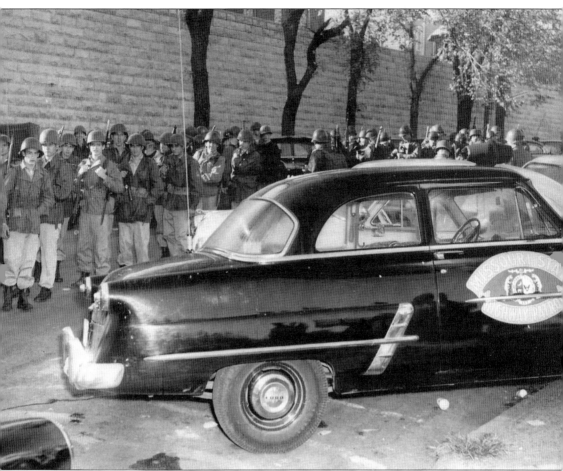

The day following the riot, on September 23, a group of National Guard troops with rifles on their shoulders stands outside one of the prison walls with a Missouri State Highway Patrol vehicle parked nearby. The night of the riot, Missouri Highway patrolmen from all over the state headed for the capital city. Truckers on the highways pulled over so troopers would have a clear path, and local police in towns along the way manned intersections to keep traffic clear. (Courtesy of the Mark Schreiber collection/Missouri State Archives.)

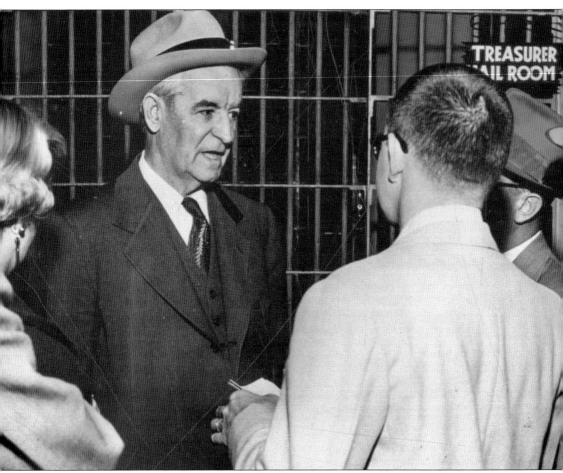

Prison and government officials conferred following the riot. Seen here is Gov. Phil M. Donnelly speaking with the press.

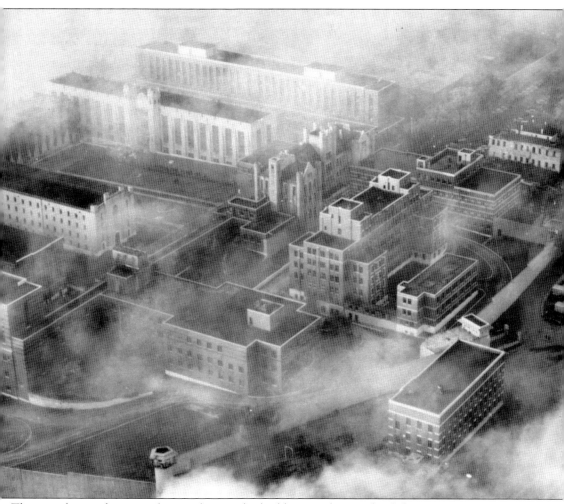

This aerial view shows smoke smothering the buildings and grounds of the state penitentiary the day after the riot. Local fire department units were hesitant to enter the grounds because rioting inmates had not been fully accounted for, which would have been a risk for firefighters attempting to put out the flames.

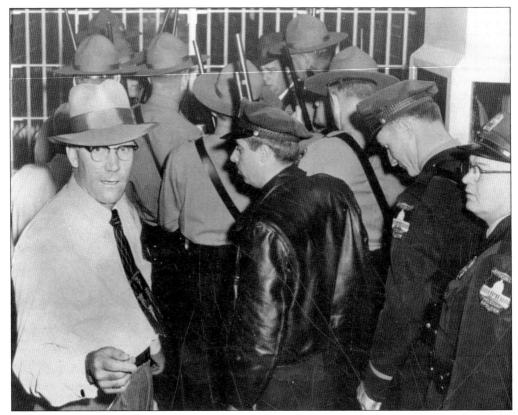

Armed officers of the Missouri State Penitentiary, the Missouri State Highway Patrol, and the Jefferson City Police Department are seen entering the round gate area on the evening of September 22, 1954, during the riot. In the foreground from left to right are Warden Ralph Edison, Jefferson City police officer Freeman Farmer, Officer Carl Montree, and Officer Gerald Heard; Col. Hugh Waggoner, superintendent of the Missouri State Highway Patrol, is in the center rear.

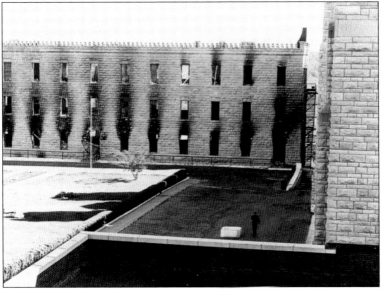

This photograph was taken after the 1954 riot. E Hall, where the riot started, appears to be badly damaged.

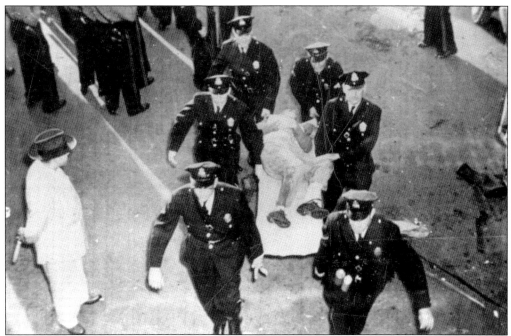

Prison guard Clarence Dietzel is carried out of the prison by six St. Louis policemen following the riot on September 23, 1954. Dietzel was held hostage by rioters and was slashed with a knife and razor and forced to lie on a fourth-floor catwalk with his legs dangling over the edge. He was held captive during the revolt in B and C Hall.

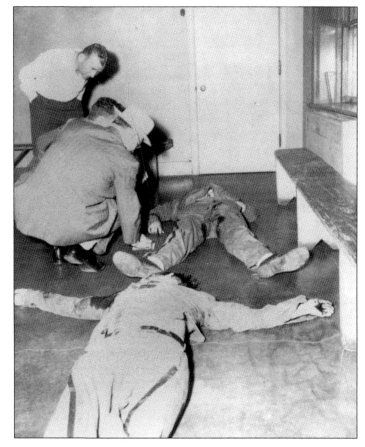

Two inmates killed in the riot are inspected by prison officials.

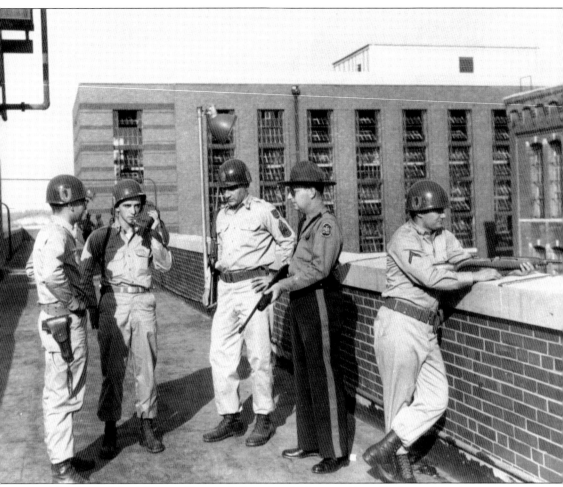

Members of the Missouri National Guard and Missouri State Highway Patrol are strategically placed around the penitentiary on a rooftop overlooking E and A Halls on the day following the riot. (Courtesy of the Mark Schreiber collection/Missouri State Archives.)

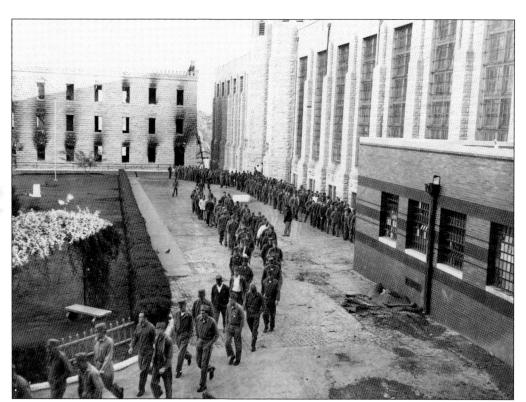

Inmates, under the watchful eye of Missouri Highway patrolmen following the riot on September 22, 1954, march in line to the dining hall.

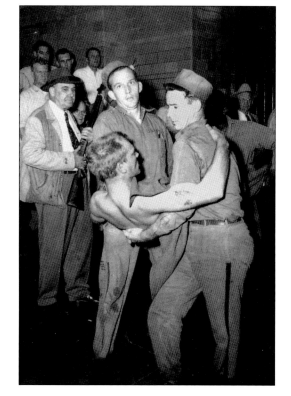

Inmates carry a wounded fellow prisoner through the Control Center lobby during the riot. The man on the left with the shotgun is associate penitentiary warden W.P. Steinhauser. (Courtesy of the Mark Schreiber collection/Missouri State Archives.)

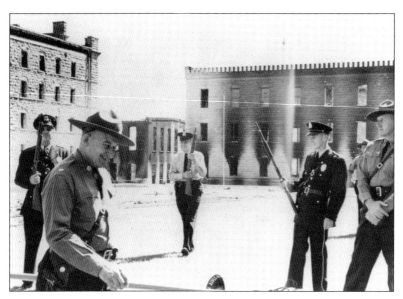

Missouri state highway patrolmen and St. Louis police officers with shotguns drawn stand in the courtyard the day after the riot. The building in the background is the burned E Hall structure, which was badly damaged during the revolt. To the left is A Hall, which was the main housing unit for African American inmates.

Following the 1954 riot, inmate labor was utilized to rebuild several structures. This building served as the library, school, and dining hall before being gutted by fire during the riot. In the background is Housing Unit 3/B and C Hall. (Mark Schreiber collection.)

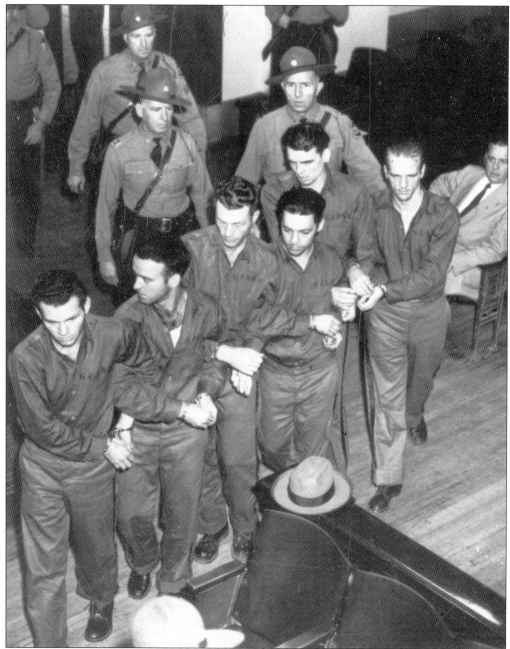

The day following the 1954 prison riot, six inmates are escorted handcuffed together into a Cole County courtroom. The men pictured are, from left to right, Donald De Lapp, age 19; William "Billy" Hoover, age 23; Jack L. Noble, age 19; Rollie Laster, age 21; Paul Kenton, age unknown; and James "Slick" Stidham, age 28. Seated in the suit is Col. Hugh Waggoner, highway patrol superintendent. Others troopers seen here are Capt. Maurice Parker (center left), Lt. Bill Barton (center right), and Sgt. Jim Judkins (upper left).

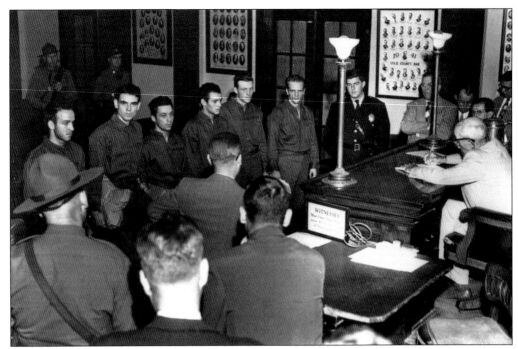

Riot leaders in Cole County Circuit Court hear the charges against them related to the murders and other violence that occurred during the riot.

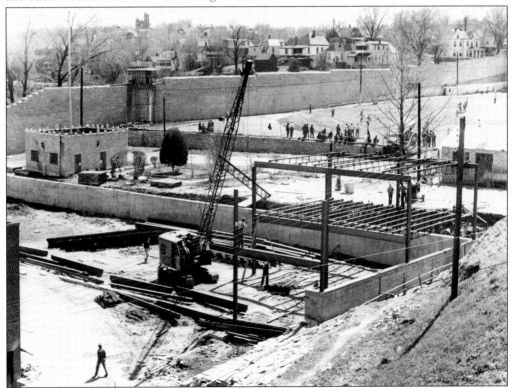

One of the prison buildings is under construction following the riot.

Four

INMATE AND
STAFF PERSONALITIES

The Missouri State Penitentiary is known for those who served out sentences behind its walls. Kate Richards O'Hare, who served a five-year sentence beginning in April 1919 for an antiwar speech in North Dakota, was deeply touched by the harsh and unfair conditions for prisoners. She wrote extensively about the horrible environment, ultimately devoting her life to prison reform.

Lee Sheldon, commonly known as "Stagger Lee," was a St. Louis waterfront worker and killer. His story became legend along the Mississippi River, and the well-known song "Frankie and Johnny" resulted. In 1953, Carl Austin Hall, a small-time crook, and his girlfriend Bonnie Brown Heady, were convicted of kidnapping and brutally murdering a young Kansas City, Missouri, boy. They both received a death sentence, but because the federal government did not have a facility for executing individuals and the crime had occurred in Missouri, the death sentence was carried out at Missouri State Penitentiary. Crime reporters from around the world came to cover the execution.

An inmate with international fame was Charles "Sonny" Liston, a poor St. Louis youth sent to prison for armed robbery. Liston learned to box in prison, and through the efforts of an African American St. Louis newspaper publisher and Catholic priest, he was granted an early parole to pursue his prizefighting career. Once paroled, Liston won the St. Louis Golden Gloves title in 1953 and the world heavyweight championship in 1962, which he held until being defeated by Cassius Clay, later known as Muhammad Ali.

And, finally, James Earl Ray was incarcerated in the penitentiary in 1960 with a 20-year sentence for holding up a Kroger store in St. Louis; however, from the day of his arrival at Missouri State Penitentiary, Ray was planning his escape. In 1967, he achieved his goal and escaped from the prison by hiding in a bread truck. The next year, he assassinated the Reverend Dr. Martin King Jr. in Memphis, Tennessee, and was sentenced in that state for the crime.

Warden Donald Wyrick, because of his keen insight and knowledge of prisons, was credited with an ability to communicate with inmates in order to find contraband and weapons and to prevent escape. It has been noted that the warden was often sought after by other states to head their penal systems.

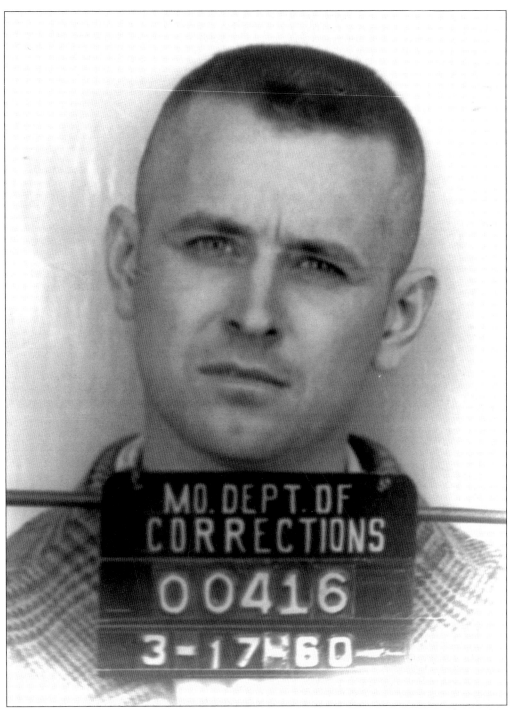

This is the March 17, 1960, booking photograph of inmate James Earl Ray. On April 23, 1967, Ray escaped from the prison in a bread truck heading to the Renz prison farm near Jefferson City. During the trip, Ray escaped and was later convicted of assassinating Dr. Martin Luther King Jr. Before that time, Ray was known to disappear in the Missouri State Penitentiary compound for days. (Courtesy of *St. Louis Magazine*.)

The two Missouri State Penitentiary officials in this photograph are recreation supervisor Glen Allen (left) and Warden Donald Wyrick. Wyrick had the longest tenure of a prison warden at the penitentiary and was the last official warden of the prison.

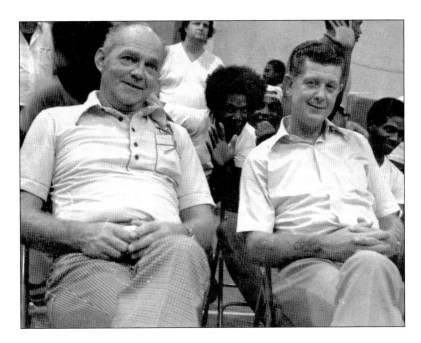

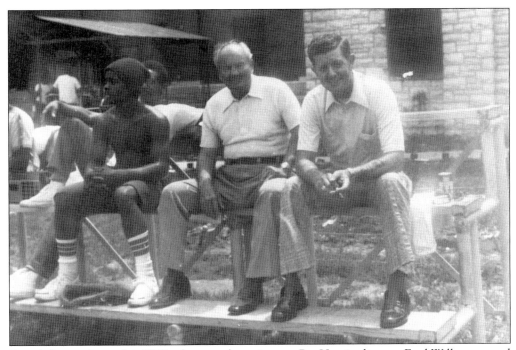

From left to right in this 1960s photograph are inmate Pat Harris, director Fred Wilkerson, and Warden Don Wyrick, who had risen through the ranks, starting as a guard and eventually leading the prison. Wyrick was able to find a considerable amount of contraband and prevent escape attempts in the institution with his extensive knowledge of prisons and ability to communicate with inmates.

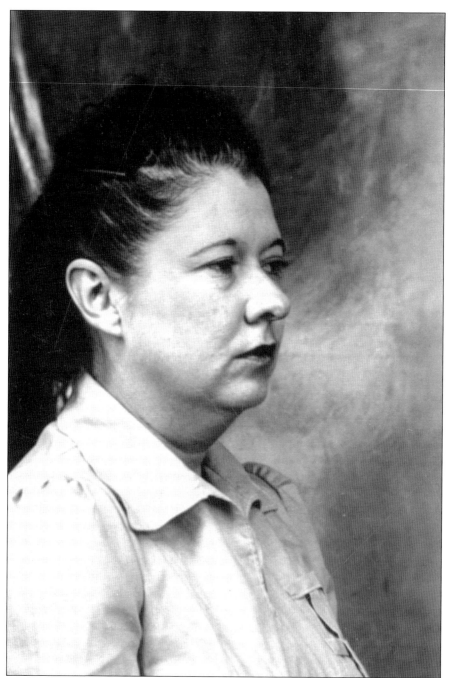

Bonnie Brown Heady and Carl Austin Hall kidnapped and murdered Bobby Greenlease, a Kansas City boy, in 1953. They were tried and sentenced to death for their crimes, but because the federal government did not have a facility for executing individuals at that time, the Missouri State Penitentiary was selected to carry out the sentence. Bonnie was executed on December 18, 1953, along with her common law husband, Carl. The gas chamber had two chairs to allow for a double execution. They were the only two people executed at the same time at Missouri State Penitentiary.

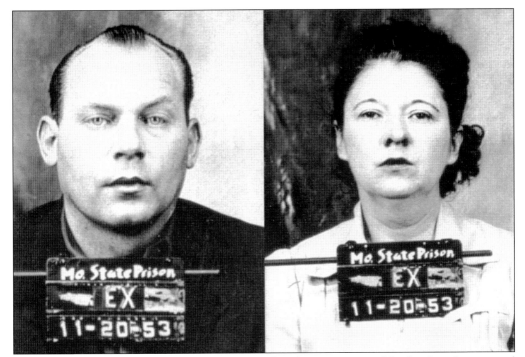

These photographs were taken of Carl Austin Hall and Bonnie Brown Heady when they entered the Missouri State Penitentiary.

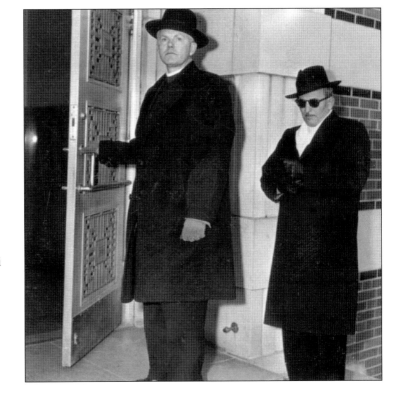

Seen on December 17, 1953, Episcopal priests Rev. George L. Evans (left) and Rev. Robert Full enter the Missouri State Penitentiary in order to visit Carl Austin Hall and Bonnie Brown Heady before the two were executed. Reverend Evans was a witness to the execution.

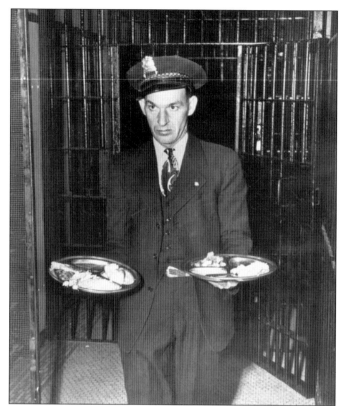

Missouri State Penitentiary custom was to allow inmates on the day of their execution to have a special dinner of their choosing prepared as a last meal. Here, a prison guard carries the last meals to inmates Bonnie Brown Heady and Carl Austin Hall before their executions.

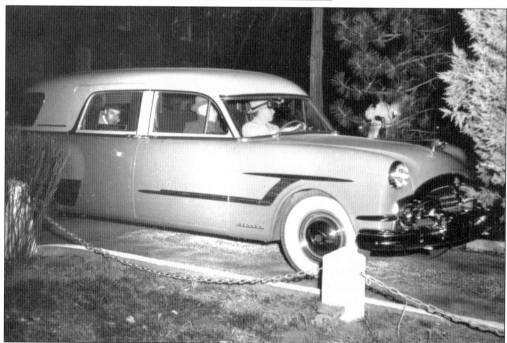

This hearse contained the body of Bonnie Brown Heady after the execution took place. Bill Branson of the Buescher Memorial Funeral Home in Jefferson City is driving the vehicle.

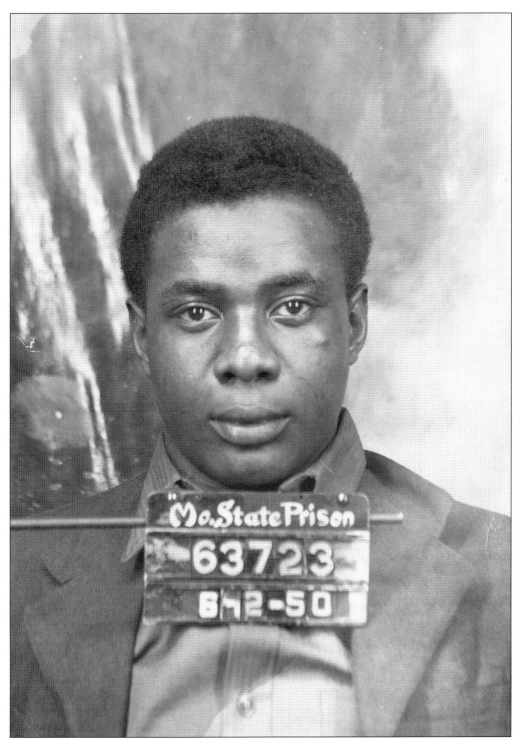

Charles "Sonny" Liston (inmate no. 63723) entered the Missouri State Penitentiary from St. Louis in 1950 to serve two concurrent five-year terms for robbery with a dangerous and deadly weapon and larceny.

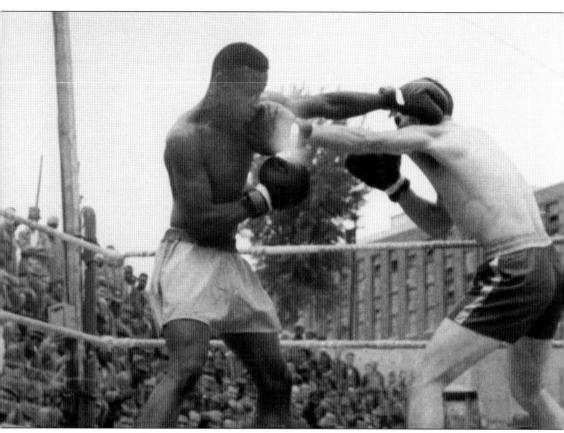

Sonny Liston is shown boxing at the Missouri State Penitentiary. A Catholic priest assisted Liston with gaining his release from prison in order for his to develop his fighting skills and the beginning of his boxing career. Liston rose through the ranks to become heavyweight boxing champ until he was defeated by Muhammad Ali. (Courtesy of Gary Kremer.)

Sonny Liston, as heavyweight champion, visits the Missouri State Penitentiary and is receiving a haircut. The man behind Liston wearing the suit is Capt. Orville Turner.

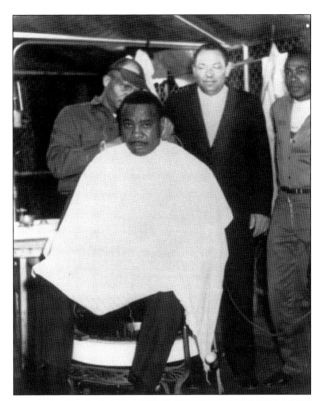

A popular intramural sport at the Missouri State Penitentiary was boxing. In this photograph, inmate prison champion Jeff Merritt (center) is seen with world heavyweight champ Joe Louis (right) and middleweight champ Sandy Saddler during their visit to the institution. (Courtesy of Gary Kremer.)

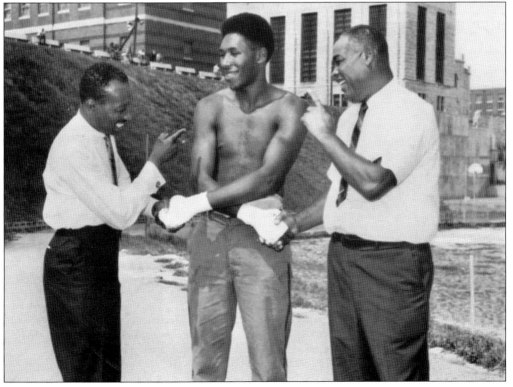

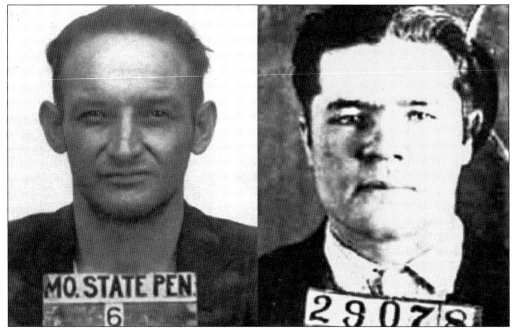

Adam Richetti (left), the getaway driver in the infamous Kansas City Massacre, was executed at the Missouri State Penitentiary in October 1938. Charles Arthur "Pretty Boy" Floyd (right) was also implicated in the well-known crime.

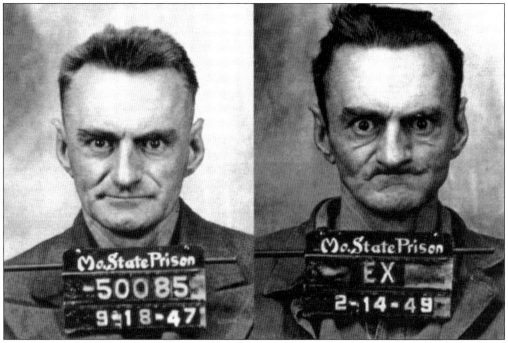

Claude McGee was executed in the gas chamber in 1951. The image on the left was taken when McGee entered the Missouri State Penitentiary in 1947, and the one on the right shows how he appeared two years later. He did not eat his last meal before being executed, instead saying, "I'm saving it for later." (Courtesy of the Jefferson City Convention and Visitors Bureau.)

Five

PRISION INDUSTRY

Early in the 19th century, the Missouri General Assembly successfully passed legislation that laid the groundwork for both the capital and state penal institution in Jefferson City. Financing state government operations was possible through state taxes. On the other hand, securing funds in support of the prison was problematic.

Initially, the state chose to lease out operation of the prison to local businessmen. These businessmen were free to utilize convict laborers and retain the profit. Local residents, however, were not in total support of this type of prison industry for two reasons: first, they feared that inmates working outside of the prison would lead to an increase in escapes; secondly, it was felt that inmate labor would take away jobs from local residents, particularly in building trades. By the 1870s, the leasing arrangement was not popular with the local community.

The second proposal for financially supporting the prison operation was a plan for private entrepreneurs to set up shops inside the prison using prison labor; however, the state would maintain administrative control over the prison. From the very beginning, this idea was attractive to local businesspeople. Large operations, including companies involved in boot and shoe manufacturing, saddle making, and other labor-intensive manufacturing industries, used Missouri State Penitentiary labor. Many of the business owners became millionaires and constructed mansions on Jefferson City streets not far from the prison, including Moreau Drive, Capitol, West Main, and East McCarty Avenues. The prison-industry program that used cheap convict labor and took jobs from Missourians was unpopular with the general public and was, over time, phased out, with the more modern idea of prisoner rehabilitation adopted.

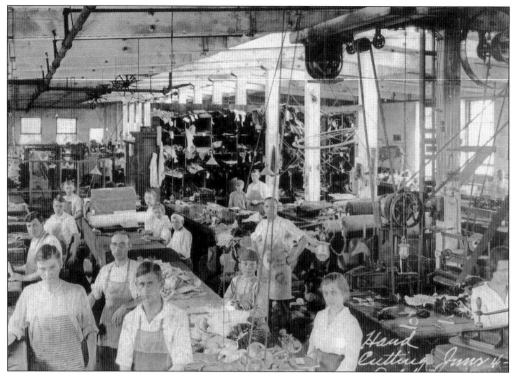

Inside the Tweedie Shoe Factory, prisoners and citizens, including youths, worked side by side. The practice was discontinued, not due to safety concerns but rather because unions were upset about losing jobs.

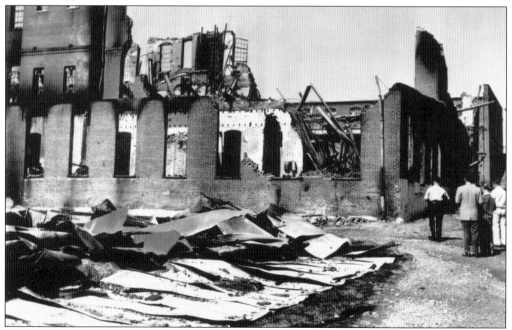

This September 23, 1954, photograph, taken after the prison riot, shows remains of the clothing factory that had burned.

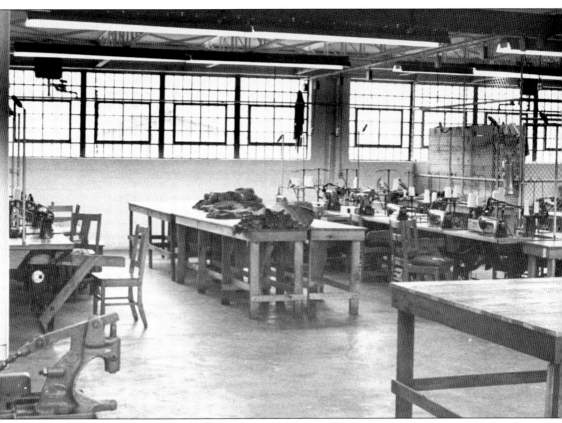

Workbenches are seen in the newly built clothing factory where prison garb was manufactured after the old factory was destroyed during the riot.

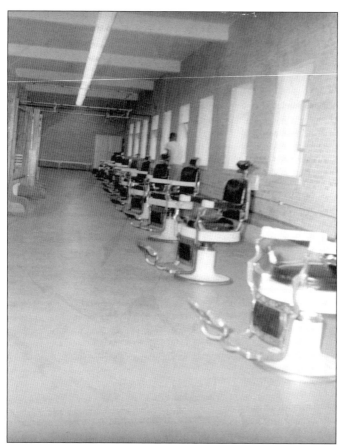

This 1953 photograph of the prison barbershop shows nine empty chairs for inmates. The shop was located in the central clothing and shower area. The chairs were purchased from the Koken Barber Company of St. Louis, Missouri. These antique chairs were removed from the penitentiary about 1980.

The Binder Twine plant, which produced rope at the Missouri State Penitentiary, was run by a private firm in a two-story brick building near the stockade area. The plant produced an astounding three million pounds of high-grade binder twine each year and was considered a model plant for its kind. A prison superintendent ran this entire factory with assistance from a guard. (Courtesy of Fast collection.)

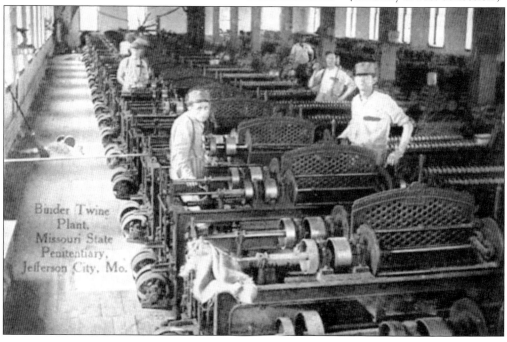

Binder Twine Plant, Missouri State Penitentiary, Jefferson City, Mo.

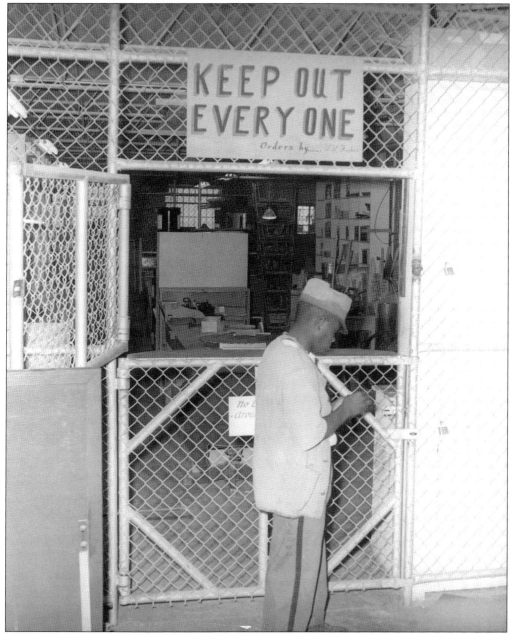

An inmate is standing in front of the tool control room in the M and M Building in the 1950s.

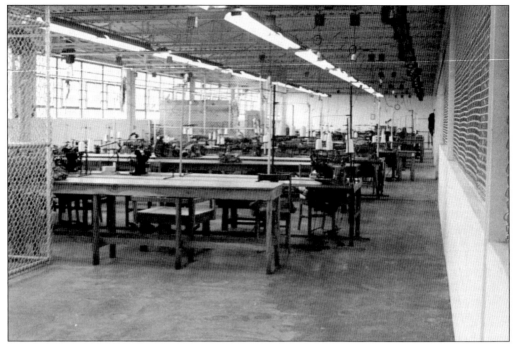

The Missouri State Penitentiary clothing factory is pictured in the 1970s with workbenches and clothing pressing machines.

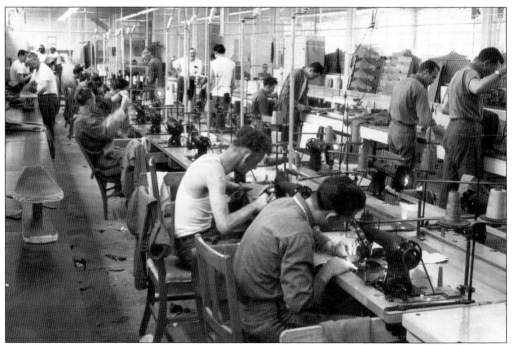

This 1959 photograph shows inmates busy at work in the clothing factory.

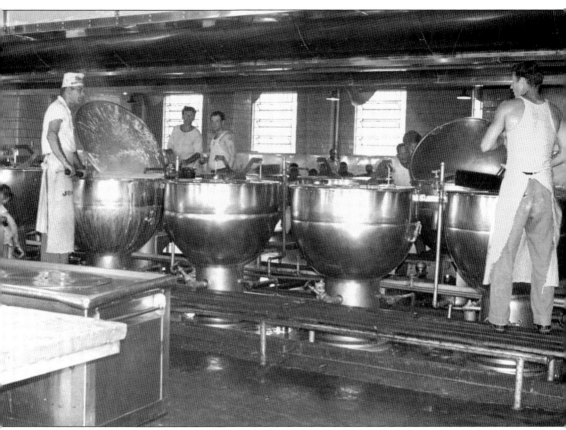

Inmates are cooking food in stainless steel vats in the prison kitchen in this 1976 photograph. Notice that because of the humid conditions many inmates wore sleeveless shirts.

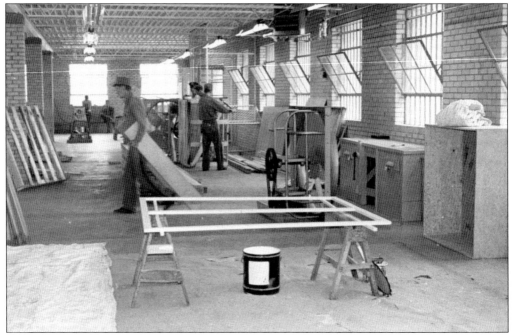

This prison workshop is pictured in the 1960s. Notice that a guard is stationed in a booth on the far right.

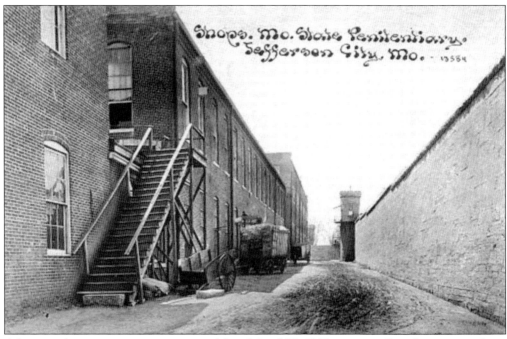

A horse and wagon are seen in a postcard dated April 20, 1908, near an alley where prison shops operated. In the distance, a prison guard stands on top of the wall near a guard tower, and a second staff person is at the base of the tower near the door. The old prison hospital is the building on the left. (Courtesy of Fast collection.)

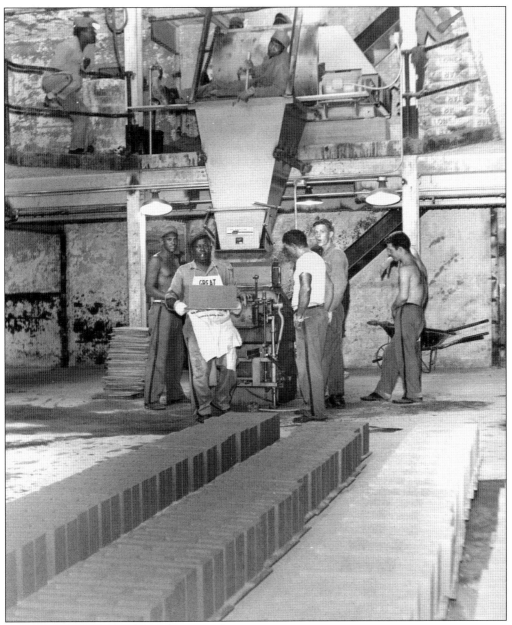

Inmates are making bricks in the prison factory.

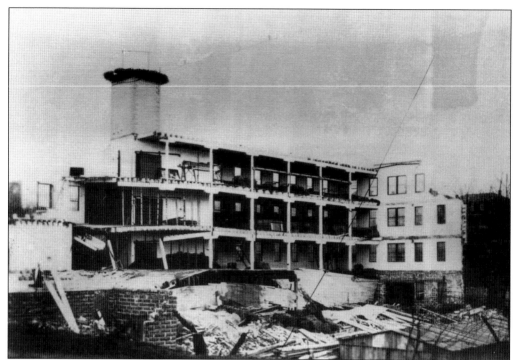

The business shown here produced brooms as the Carson Broom Factory. Originally located in the prison, around 1920 the building was almost destroyed by a bomb before it could be occupied because union laborers were unhappy with the use of cheap prison labor. The first floor was rebuilt and is now home of the Shryack and Hurst Wholesale Grocery Company. (Courtesy of the Summers collection/Missouri State Archives.)

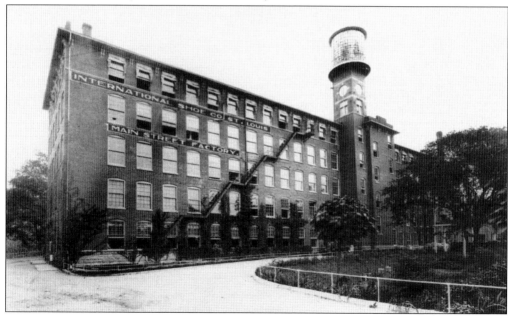

The factory building of the International Shoe Company of St. Louis in Jefferson City is pictured here.

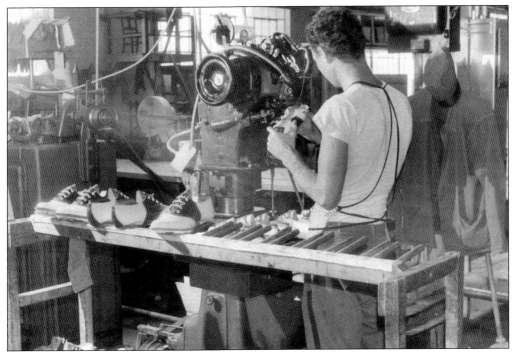

Inmates work in the shoe factory in 1959. Notice that inmates wore pants with a stripe running down the leg in this era of the penitentiary.

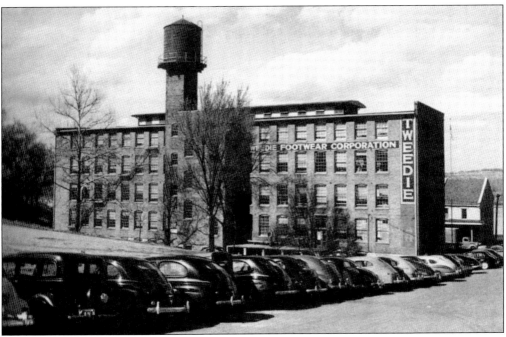

A large employer in the Jefferson City economy was the Tweedie Shoe Factory. This company was started with inmate labor inside the Missouri State Penitentiary before moving to this location on the 100 block of Jefferson Street during the early 20th century.

This is a retaining wall by the shoe factory that was damaged by the 1954 riot. The wall was subsequently repaired.

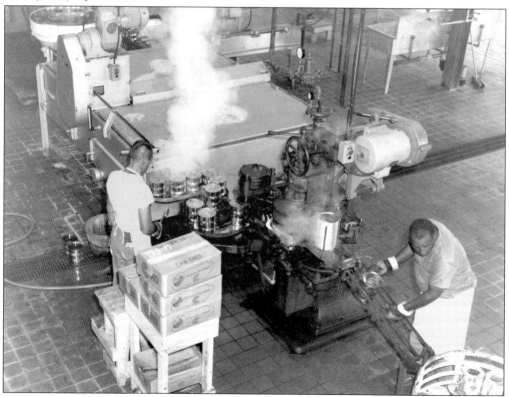

Inmates are working in one of the canning factories.

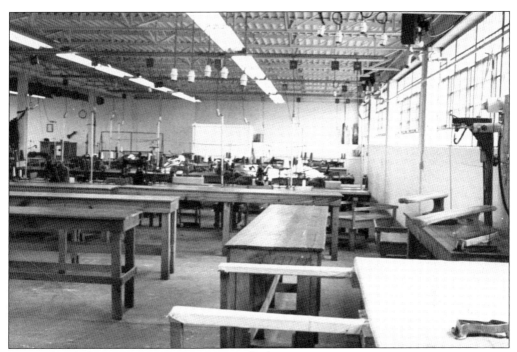

This is the clothing manufacturing room inside the prison.

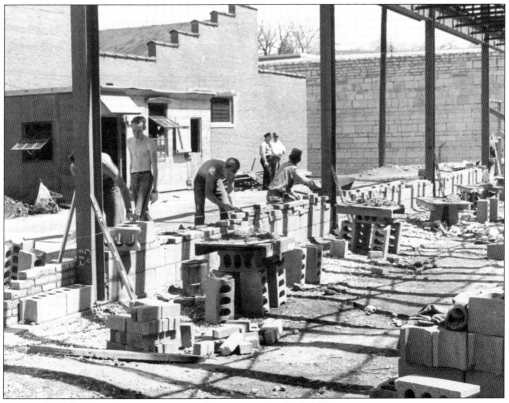

Inmate bricklayers are constructing a factory on April 25, 1957.

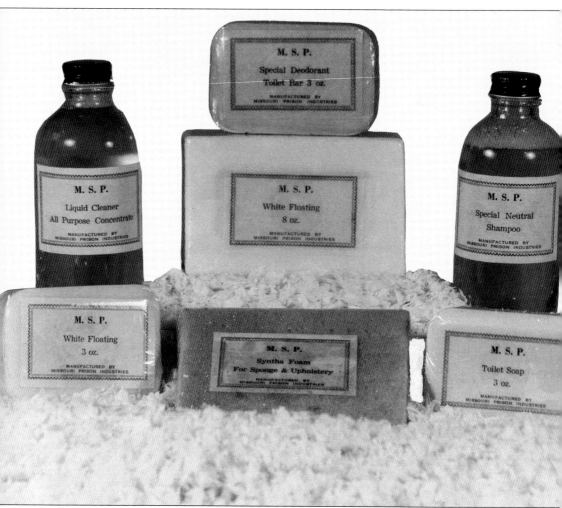

These products were produced in the soap factory. The bottles are filled with Liquid Cleaner All Purpose Concentrate (left) and Special Neutral Shampoo (right). The soap in the back center includes three ounces of Special Deodorant Toilet Bar (above) and eight ounces of White Floating (below). The soaps in front are, from left to right, another three ounces of White Floating, Sybtha Foam for Sponge and Upholstery, and three ounces of Toilet Soap.

BIBLIOGRAPHY

Brooks, Michelle. "A Look Inside the Walls." *Jefferson City News-Tribune*. March 29, 2009.
———. "H-Hall History." *Jefferson City News-Tribune*. October 10, 2010.
Early, Rosalind. "Escape Artists—It's Hard to Keep a Bad Man behind Bars," *St. Louis Magazine*. February 2012.
Edwards, Ra'Vae. "City Prospered after Civil War," *Jefferson City News-Tribune*. November 26, 2008.
Heartland History: Essays on the Cultural Heritage of the Central Missouri Region, Volumes 1 and II. St. Louis: G. Bradley Publishing Inc., 2000 and 2001.
Heartland History: Essays on the Cultural Heritage of the Central Missouri Region, Volume III. Jefferson City, MO: City of Jefferson, 2004.
Kremer, Gary R. *Exploring Historic Jefferson City*. Jefferson City, MO: City of Jefferson, 2003.
Parks, Arnold G. *Jefferson City*. Charleston, SC: Arcadia Publishing, 2010.
Schreiber, Mark S. *Shanks to Shakers*. Jefferson City, MO: Jefferson City Convention and Visitors Bureau, 2011.
Stout, Laurie A. *Somewhere in Time: 170 Years of Missouri Corrections*. Jefferson City, MO: Missouri Department of Corrections, 1991.
Sturdevant, Craig. *Cultural Investigations Phase II Testing*, unpublished report. Cole County, MO: MSP Redevelopment Project, June 2011.
Summers, Joseph S. *Pictorial Folk History of Jefferson City, Missouri 1890–1900*. Jefferson City, MO: Summers Publishing, 1986.
Summers, Dr. Joseph S. and Dorothy Dallmeyer. *Jefferson City, Missouri*. Charleston, SC: Arcadia Publishing, 2000.
"Touring the Joint," *St. Louis Post-Dispatch*. May 3, 2009: p. T–1.

DISCOVER THOUSANDS OF LOCAL HISTORY BOOKS FEATURING MILLIONS OF VINTAGE IMAGES

Arcadia Publishing, the leading local history publisher in the United States, is committed to making history accessible and meaningful through publishing books that celebrate and preserve the heritage of America's people and places.

Find more books like this at
www.arcadiapublishing.com

Search for your hometown history, your old stomping grounds, and even your favorite sports team.